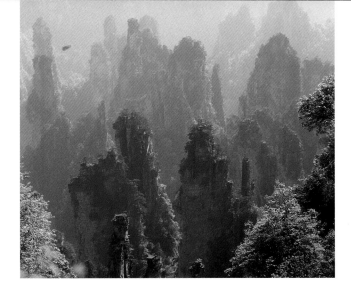

# Famous Mountains and Rivers

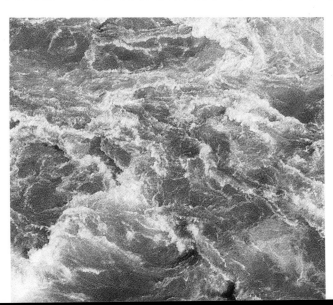

**"Culture of China" Editorial Board:**

**Consultants:** Cai Mingzhao, Zhao Changqian, Huang Youyi and Liu Zhibin
**Chief Editor:** Xiao Xiaoming
**Board Members:** Xiao Xiaoming, Li Zhenguo, Tian Hui, Hu Baomin,
　　　　　　　　　Fang Yongming, Hu Kaimin, Cui Lili and Lan Peijin

**Editors:** Cai Lili, Cheng Yu
**Translated by:** Cheng Yu, Gu Wentong
**English Text Editor:** Yu Ling
**Photographers:** Liu Chungen, Sun Yongxue, Sun Shuming, Sun Zhijiang,
　　　　　　　　　Luo Wenfa, Gao Chunrui, Xie Jun, Du Zequan, Gu Weiheng,
　　　　　　　　　Ru Suichu, Liu Shizhao, Fang Haifeng, Lang Qi, Huang Lukui,
　　　　　　　　　Wang Chunshu, Xu Mingqiang, Tong Yongjiang and Zhang Yunlei
**Layout Designer:** Cai Rong
**Cover Designer:** Cai Rong

First Edition 2002

**Famous Mountains and Rivers**

ISBN 7-119-03063-9

© Foreign Languages Press
Published by Foreign Languages Press
24 Baiwanzhuang Road, Beijing 100037, China
Home Page: http://www.flp.com.cn
E-mail Addresses: info@flp.com.cn
　　　　　　　　　sales@flp.com.cn
Distributed by China International Book Trading Corporation
35 Chegongzhuang Xilu, Beijing 100044, China
P.O. Box 399, Beijing, China

*Printed in the People's Republic of China*

# Famous Mountains and Rivers

Foreign Languages Press  Beijing

# Contents

Preface by *Xie Ninggao*

# Preface

*Xie Ninggao, Professor at Beijing University*

Traveling through the old and mysterious, yet dynamic land of China is like going back in time: the eternal beauty of its famous mountains and rivers is the result of millennia of history. Through travel, one can truly experience the harmony of nature and history. One can also capture beautiful scenery on film and dream freely under the boundless vault above.

The culture of China's mountains and rivers has accumulated through humanity's development, and today they have several cultural functions: offering sacrifices to gods or ancestors, *fengchan* (offering sacrifices to heaven and earth), sightseeing, religion, and retiring from public life to study. Emperors offered sacrifices to the Five Great Mountains and the Four Large Rivers; local governments officials sacrificed to regionally famous mountains and rivers; and common people, to a local landmark. The Five Great Mountains are Mount Taishan in the east, Mount Huashan in the west, Mount Hengshan in the south (Hunan), Mount Hengshan in the north (Shanxi), and Mount Songshan in the center. The Four Large Rivers are the Yellow, Yangtze, Huaihe and Jishui rivers. The worship of mountain and river gods is a universal phenomenon in human development, and indeed the Chinese emperors offered sacrifices to them. *Fengchan* is a grand rite of offering sacrifices to heaven and earth held by the emperors in ancient China, in which *feng* refers to the emperor's climb up Mount Taishan to offer sacrifices to heaven and *chan* refers to offering sacrifices to the earth at a mound at the foot of Mount Taishan.

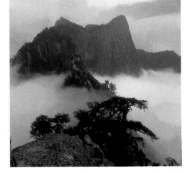

During the Han Dynasty, as Taoism first developed and Buddhism was introduced, religion began to hold increasing influence in people's spiritual lives. According to Taoism, immortals tend to live on well-known mountains, so believers climb the mountains to strive to attain the highest state of spiritual enlightenment and become immortals. Buddhism requires the followers to completely forsake their worldly desires through austere religious discipline. Buddhists refer to famous mountains as "immortals' mountains and Buddhist kingdoms" apart from the human world. Thus they believe that well-known mountains and scenic spots are ideal places for religious activities.

Mountains and rivers are also places for people to visit independently for their beauty. Especially after the second century, poets, painters, scholars, monks, and Taoists who loved well-known mountains and rivers abandoned themselves to nature and often gathered to appreciate the beautiful views and build Taoist temples. Therefore,

profound cultural content has been integrated into the development of well-known mountains and scenic spots ever since ancient China.

People of past dynasties adhered strictly to the principle of building according to topography in construction around scenic spots, thus famous mountains and rivers in China have maintained their natural features despite thousands of years of integration with the cultural landscape.

The natural beauty of mountains and rivers includes beauty of both form and color as well as dynamic and static beauty. Beauty of form is the foundation of the natural beauty of mountains and rivers.

The natural beauty of mountains and rivers can be categorized as grand, strange, dangerous, beautiful, secluded, and profound.

What kind of natural landscape is called "grand"? It mainly refers to loftiness of mountains, or their relative heights. For example, "Mount Taishan (on the eastern end of the North China Plain) is the world's grandest" because of its great relative height. The mountain towering above other hills in Shandong Province looks extraordinarily lofty and magnificent.

What kind of landscape is called "strange"? Strange landscapes are unusual, defying all expectations. Mount Huangshan is regarded as "the most spectacular in the world," because its stones, green pines, sea of clouds and springs are full of surprises and do not resemble other mountains. Its fantastic precipitous peaks range in pleasantly contrasted shapes and heights, with 72 peaks over 1,000 meters and some shooting abruptly to the sky. Its unique stones are characterized by a great variety of shapes and postures. Its fantastic pines, with their twisted roots and curling branches, are either suspended between dangerous rocks, or they grow on cliffs by breaking through the rock. Its ceaselessly changing sea of clouds looks like a snowy sea when peaceful, and roaring waves when moving. Its springs not only include lakes, brooks, ponds, and waterfalls, but also include hot springs that flow all year round, neither drying up nor overflowing. The stones, pines, clouds, and water are wonders of infinite change and harmoniously integrate with one another.

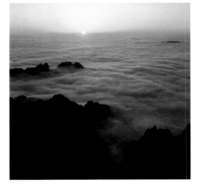

What kind of landscape is called "dangerous"? Steep precipices, deep valleys and towering sheer cliffs constitute a dangerous landscape. A Chinese saying describes the precipitous terrain: "From ancient times, there has been only one path up to (the summit of) Mount Huashan." From a bird's eye view, the mountain rises abruptly out of the surrounding hills like a heavenly pillar cut by an axe. The slopes have inclines of 80 to 90 degrees, and peaks and

valleys may differ a thousand meters in height. Mount Huashan's main peak is over 2,000 meters above sea level. To reach the peak, visitors must hold onto iron chain railings and travel on dangerous paths and cross the "Thousand-*Chi* (a unit of measurement) Stone Pillar," "Hundred-*Chi* Gorge," "Cliff Brushing One's Ears," and "Stairway to Heaven." Perilous peaks of famous mountains are usually the most attractive scenic spots.

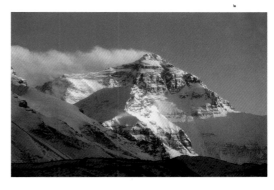

What kind of landscape is called "beautiful"? There are three conditions: first, well-shaped, gently rolling mountains with solft and pleasant contours; second, an excellent ecological environment and a high rate of vegetation coverage; third, murmuring streams and gurgling limpid springs. Such a mountain should have both green hills and clear waters. With ample rainfall and luxuriant vegetation, southern China is well known for its beautiful landscape, such as Mount Emei, West Lake, and Guilin, noted respectively for being grandly beautiful, delicately beautiful, and strangely beautiful in addition to the above common features.

What kind of landscape is called "secluded"? Secluded landscapes usually have high mountains and deep valleys, basins between mountains, level land at the foot of the mountain, and towering trees forming semi-enclosed spaces. The quiet, tranquil scenes are characterized by narrow visibility, low light, clean air, and multiple layers of depth of the field of view, with the subtlety of zigzag mountain paths, but without taking in everything at a glance immediately. Such landscape is often seen in a small basin surrounded by mountains on three or four sides, with one or two exits, of which the one facing south is best, for it is suitable for China's monsoon climate, i.e., keeping off the northwest wind in winter and facing the southeast wind in summer. These treasured places are usually ideal for building temples and academies of classical learning at famous mountains and rivers, including Tiger-Taming Temple of Mount Emei and White Deer Cave Academy of Mount Lushan.

What kind of landscape is called "profound"? It is more quiet and isolated than a secluded landscape. Surrounded by cliffs, the passageways of a profound landscape look like zigzag rock cracks as deep as a well. It may also include caves. The towering peaks of Wulingyuan and deep valleys along Gold Whip Stream inspire intrigue and mystery. They are surrounded by sheer precipices hundreds of meters high, overhanging rocks and towering fantastic peaks everywhere. All is covered by luxuriant vegetation, and one cannot see daylight until noon. It is a typically profound scenic spot.

The ancients left many comments on the images of well-known mountains and rivers. For example, according

to their general impressions, Mount Taishan is grandest in the world; Mount Huangshan, the strangest; Mount Huashan, the most dangerous; Mount Emei, the most beautiful; and Mount Qingcheng, the most secluded. In fact, however, every well-known mountain and river contains the basic characteristics of being grand, strange, dangerous, beautiful, secluded, and profound.

Nature's beauty does not only lie in the towering peaks, tiny but exquisite stones, or the rolling waves of the rivers and seas, but also the varied beauty of colors.

In its pure form, water is colorless and transparent. However, water can change color depending on the different minerals or other impurities present. The golden rolling waves of the Yellow River, with its high silt content, are a splendid sight. The white waves of the Jinsha River and the green waves of the Fuchun River are also

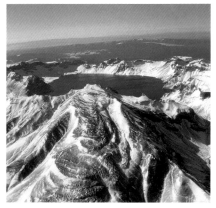

striking. The water of Jiuzhaigou is the most beautiful in the world, not only because of its various states such as lakes, streams, pools, and waterfalls, but for its purity. It looks like snow falling onto jade when moving in waves, and emerald when at rest. Even more beautiful than being crystal clear, the water looks colorful, bright and sparkling due to the mineral content.

The blue sky with white clouds is always a beautiful sight. Famous mountains often also have beautifully colored sky scapes, such as the beautiful sunrise views at the Sun Watching Peak of Mount Taishan—famous for the glowing rays in all directions—or the setting sun at the Pavilion for Dispelling Clouds of Mount Huangshan, with its rosy evening clouds across the sky.

Vegetation—and even life—is at its richest when the color green serves as the foundation, with highlights of colorful flowers. Many famous mountains and rivers in China have their own special local flowers, such as Mount Emei's alpine azaleas, which provide a grand view of bright colors. Each of the four seasons presents a different setting for vegetation.

Changes of weather, such as cloudy, sunny, rainy, or snowy weather, color nature views in different ways and provoke different emotional responses. Poets and painters have long appreciated a spotless white snow-covered landscape, a rare sight worth seeing for tourists. Xu Xiake, a famous scientist, traveler and writer of the Ming Dynasty, was greatly moved by the beautiful snow-covered landscape of Mount Huangshan when he first climbed it, leaving such descriptions as, "Covered with snow, the stone staircases look like jade." The lofty icebergs and snowy peaks of the Qinghai-Tibet Plateau have long attracted Chinese and foreign explorers. Mount Gongga of Sichuan, Mount Tianshan, the Heavenly Pond of Xinjiang, and the Jade Dragon Snow Mountain of Yunnan are well-

known national scenic spots, and have attracted tourists both from home and abroad. Light clouds and thin mists often cover the mountains with a layer of subtle color, making the mountain peaks more gentle, elegant and harmonious. The morning mist covers many stones, branches and leaves like organza fabric, and as a result, the ranges of distinct peaks look more like a unified whole, which seems more profound. For example, the karst needles of Guilin look more beautiful when observed from a distance than up close, and under back light rather than front light. They look most sublime when surrounded by light clouds and thin mist. As southern China is humid, the scenic spots are especially charming in the continuous rain, misty weather, or in the morning sunlight and the mist of the setting sun.

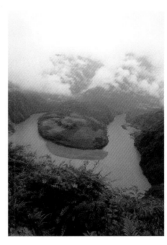

Water, the blood vessel of mountains and the fountainhead of life, is the most active dynamic ingredient in scenery; hence the view that water enlivens mountains. It is characterized by many forms, such as relatively quiet lakes and ponds, constantly flowing streams and rivers, and fast changing waterfalls and angry waves. A waterfall on a mountain presents the static beauty of a bolt of white silk hanging down from the sky when appreciated in the distance; observed closely, it presents the dynamic beauty of a hurricane falling from the Ninth Heaven. The surging Yangtze River endows the Three Gorges with breath-taking sense of beauty. Other scenic spots of dynamic beauty include the Huangguoshu Waterfall of Guizhou Province and the Sandiequan Waterfall of Mount Lushan.

Flowing clouds and floating mists rise slowly from deep valleys, and are carried by the wind over ridges and peaks, half hiding and half revealing them. This landscape forms the artistic conception of "mountains in a vague and insubstantial environment," which has also been a form of dynamic beauty of the landscape since ancient times. We can master the general rules of cloud and mist, an unstable essential factor of dynamic beauty, and capture its beauty by scientifically analyzing the climate characteristics of scenic spots. Clouds and mist are more changeable than water, sometimes surging and rolling like waves, sometimes floating leisurely, sweeping past slowly. In such an environment, one feels as though one is roaming an enchanted land.

The beauty of the images and colors of mountains and rivers, as well as their dynamic and static beauty, is primarily visual in nature. Famous mountains and rivers also possess the beauty of the senses of hearing and smell, such as the singing of birds and the fragrance of flowers. Waterfalls falling down into deep pools, violent waves lapping against the banks, streams flowing through mountains, springs rushing into clear ponds, plantains being beaten by rain, the wind rustling in the pines, birds singing in a peaceful and secluded forest, and insects' calls at

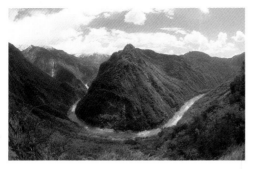

night: all this constitutes a natural symphony. It is undoubtedly a great enjoyment for the people living in the bustling cities for a long time to appreciate the rustling of the wind in the pines of Mount Huangshan, the waterfalls and springs of Jiuzhaigou, the sonata of the "frog playing piano" at the Ten-Thousand-Year Temple of Mount Emei, the roaring surf in the Cave of Tide Sounds of Mount Putuoshan, and the fragrance of sweet-scented osmanthus flowers at Mount Jinggang.

Besides natural beauty, the beauty of landscapes is also reflected in items of cultural interest, including buildings, inscriptions on precipices, and local customs.

Artificial constructions are best kept small and unobtrusive, so that the site's natural beauty is highlighted. Places of human interests are often just a few small-scale buildings scattered in hidden sites of natural scenic spots, maintaining both a pristine landscape and the particular beauty of the cultural interest. The buildings do not impose on the natural environment; they look as though they are growing out of their surroundings. This constitutes a beautiful symphony of nature and man.

For example, the scenic spot of the South Gate of Heaven of Mount Taishan is famous for its grandeur. The South Gate of Heaven is at the end of three Eighteen Mountain Bends with 1,633 steps. The gate is on the horizon. This towering scene is called "Scaling Ladders of the Gate to Heaven." The scene is aptly described by the Chinese phrase, "misty paths with a thousand mountain bends," so that one feels as though one is "reaching the horizon."

Another example is the quiet Pervading Light Temple, which is hidden in a deep and secluded valley, like a peach orchard. It is especially peaceful and secluded when the evening drum or morning bell resounds through the valley.

Besides buildings, places of cultural interest also include historical relics and inscriptions on precipices. The latter, a wonderful form of art in the culture of Chinese scenic spots, highlights the natural beauty with the art forms of literature, calligraphy, and engraving. Well-known examples include the inscriptions on precipices of the Sutra Rock Valley of Mount Taishan, and the view of Mount Lushan called "Looking Far at the Flowing Clouds."

As China has countless beautiful scenic spots, the ones introduced in this small picture album are only a fraction of the famous mountains and rivers in China. Many other famous or unknown scenic spots are to be explored and discovered. Let's follow the road less traveled and discover the unknown, beautiful views, and savor our unique experiences.

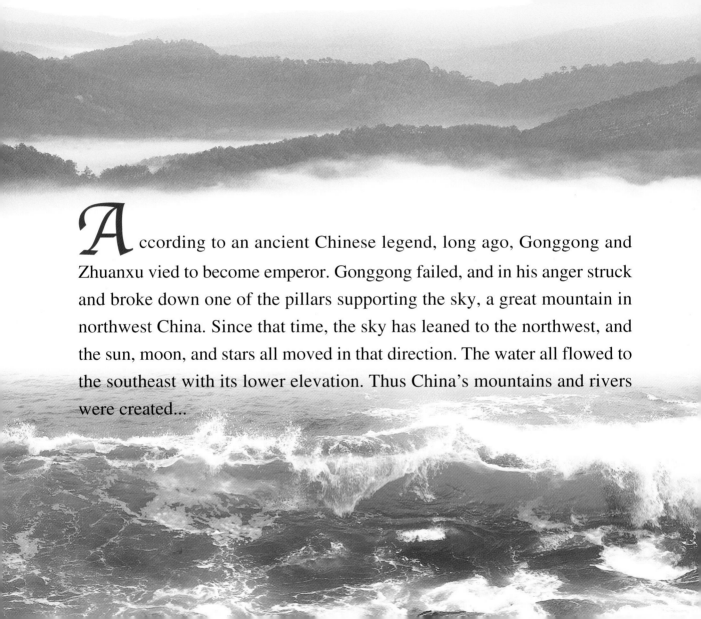

*A*ccording to an ancient Chinese legend, long ago, Gonggong and Zhuanxu vied to become emperor. Gonggong failed, and in his anger struck and broke down one of the pillars supporting the sky, a great mountain in northwest China. Since that time, the sky has leaned to the northwest, and the sun, moon, and stars all moved in that direction. The water all flowed to the southeast with its lower elevation. Thus China's mountains and rivers were created...

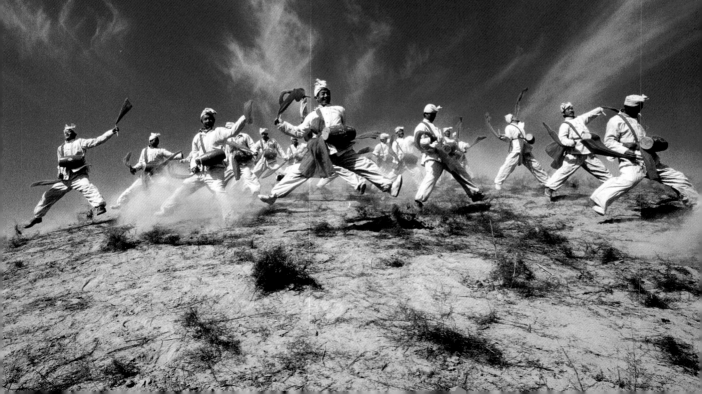

The Yellow River is the cradle of the Chinese nation and also the source of Chinese culture. Along the Yellow River, plateaus and mountains complement each other's magnificence. The scenery seems to reflect the straightforward and simple character of the people of northern China.

Shaanxi on the Loess Plateau is famous for the Ansai waist drum dance.

people often call the basin the "cradle of Chinese civilization."

Named after the muddiness of its water, the Yellow River is the most heavily silt-laden river in the world.

Divided into three stages, the Yellow River has both interesting geography and history. In the upper reaches, the river runs through a large but thinly populated mountainous area; in the middle reaches, the river passes through the Loess Plateau—the primary source of sediment—and carries the silt downstream.

## The Yellow River

The Yellow River, the second longest river in China, originates at Mount Yagradagze in the far west of the country, winding from north to south and flowing east for 5,464 km until it reaches the sea. Lying in approximate latitudes to the states of Virginia, Kansas, and Nevada in America, and countries like Greece and Turkey in the West, the Yellow River drains a basin of 745,000 sq km, nourishing 120 million people. Chinese civilization emerged in the Yellow River basin and Chinese

When passing from mountain regions to the flat plain, the river descends from an altitude of 4,575 m above sea level at the source to 1,000 m at Hekouzhen and 400 m at Zhengzhou, the capital city of Henan Province; in the lower reaches, the river channel is much higher than the surrounding land, forming an above-ground river.

The Yellow River has been the most difficult river to tame in China. The history of the Yellow River civilization is the history of taming the river. For visitors, the roaring torrent is another attraction of the Yellow River.

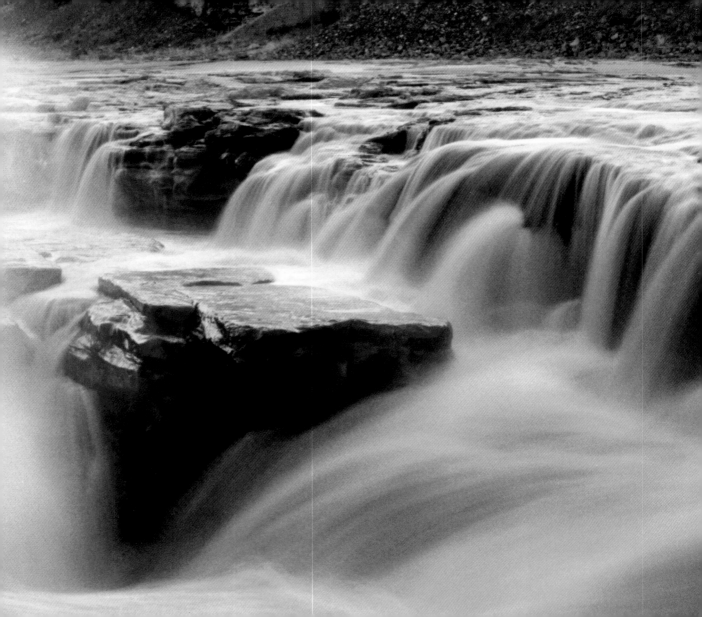

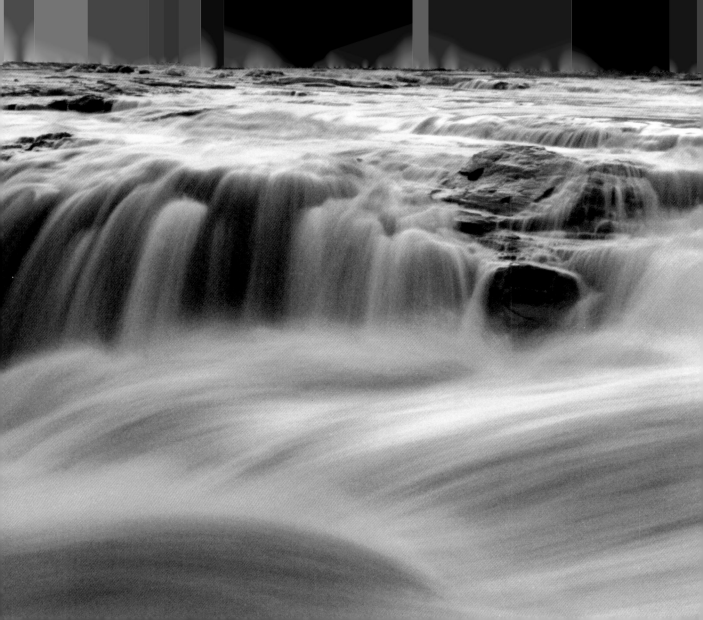

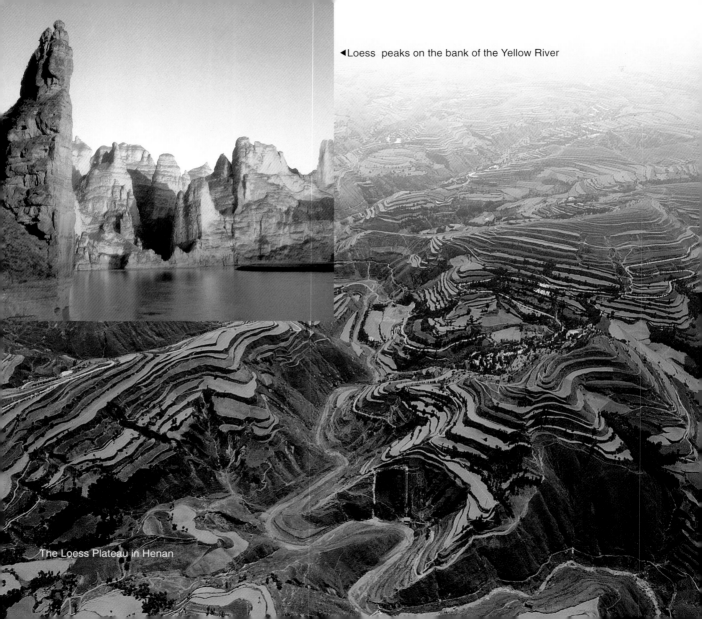

◀Loess  peaks on the bank of the Yellow River

The Loess Plateau in Henan

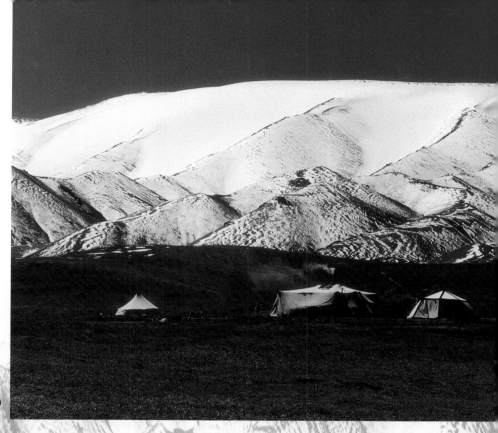

The towering Kunlun
Mountains

# Kunlun Mountains

From the Pamir Plateau to eastern Tibet, from Qinghai to Sichuan, the Kunlun Mountains extend over a wide area. Because of its mighty size, the Kunlun Mountains have been acclaimed as the "Backbone of Asia" and "Ancestor of all mountains." The highest peak in the Kunlun Mountains is Qogir Peak, the second highest peak in the world, with an altitude of 8,611 m. The Yinsugaiti Glacier on the northern slope is over 40 km long, the longest modern glacier in China. The magnificent Kunlun Mountains are often taken as the symbol of China's mighty mountains.

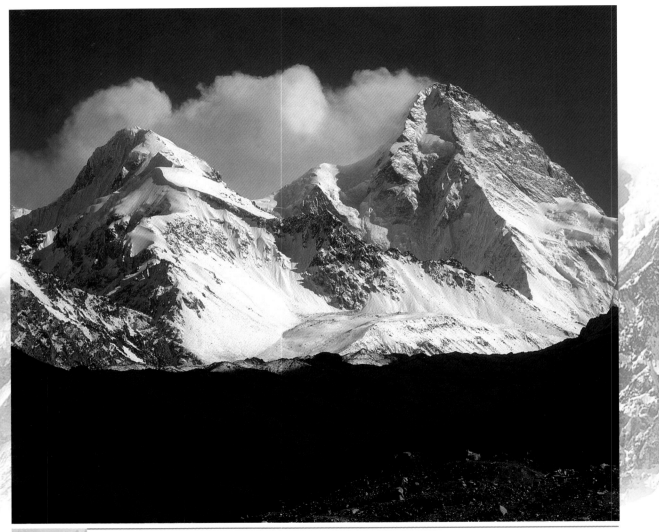

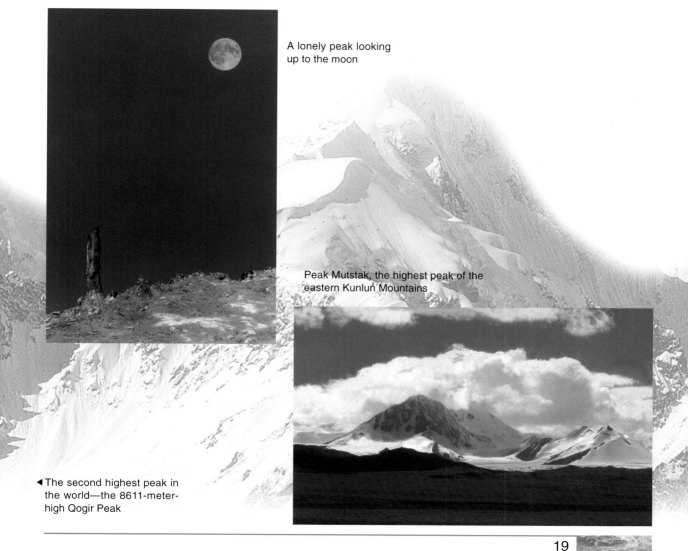

A lonely peak looking
up to the moon

Peak Mutstak, the highest peak of the
eastern Kunlun Mountains

◄ The second highest peak in
the world—the 8611-meter-
high Qogir Peak

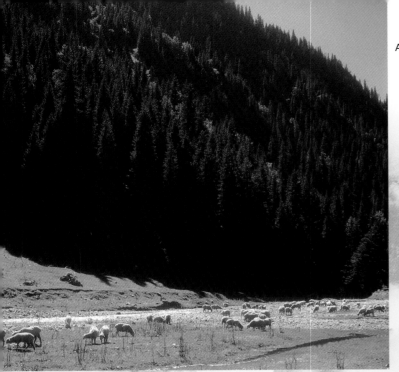

A Beautiful pasture at Tianshan

Mount Tianshan at twilight ▶

Heavenly Pond

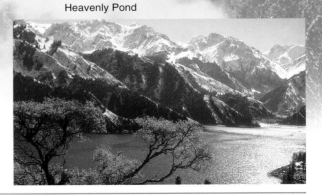

## Mount Tianshan

Mount Tianshan, or Heavenly Mountain, is in the north-western region of Xinjiang Uygur Autonomous Region, with the Dzungarian Basin to the north and the Tarim Basin to the south. Although the driest desert in Asia, the vast Taklamakan, is in the Tarim Basin, Mount Tianshan is abundant in water resources. The large waterfalls of snow, the water-protecting forest, and the beautiful mountain lake Tianchi (Heavenly Pond) are the attractions of mysterious Mount Tianshan.

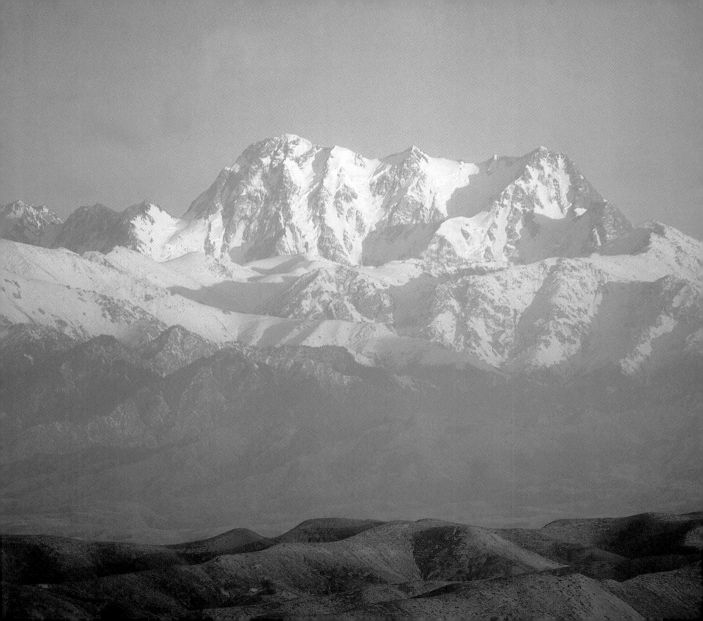

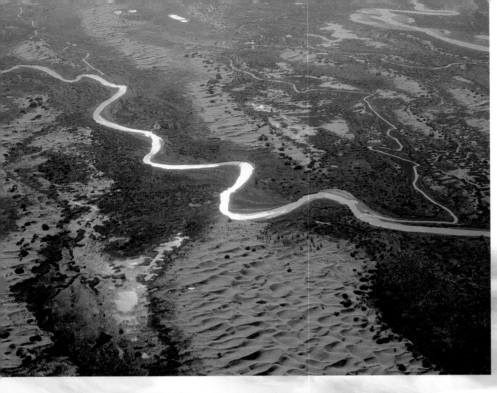

The mother river of people of Xinjiang—the Tarim River— winds through the Taklamakan Desert.

# The Tarim River

The Tarim River in the Xinjiang Uygur Autonomous Region is the longest continental river in China. From west to east, the river traverses a great desert, with a total length of 2,179 km and a drainage area of 198,000 sq km. Nicknamed the "wild horse without reins," the Tarim River has its source in the melted snow from Mount Tianshan and the Kunlun Mountains, combined with its three tributaries, the Aksu, Hotan and Yarkan Rivers. The lower reaches of the Tarim River have run dry for many years because of environmental degradation. The clear water and the green corridor consisting of a vast stretch of poplars are now only memories. Fortunately, some parts of the Tarim River are beginning to run again after years of efforts in ecological improvement.

22

The Tarim River in autumn

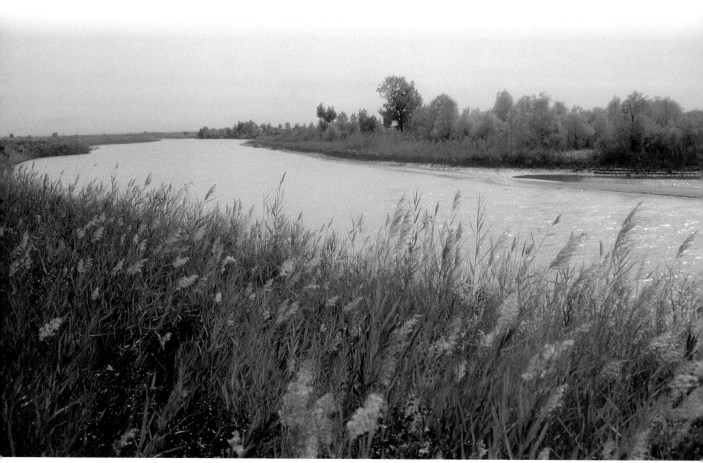

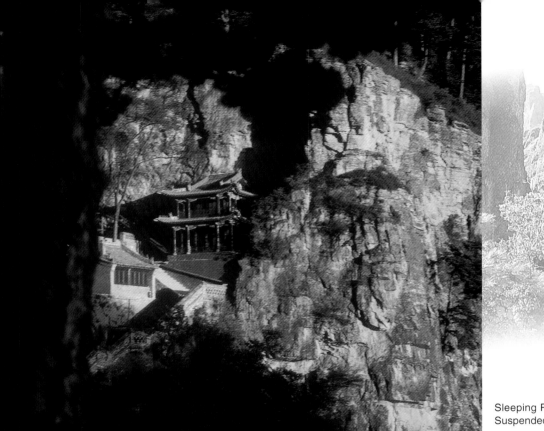

Sleeping Palace of the
Suspended Temple

## Mount Hengshan (Shanxi)

Known as the North Mountain among the Five Great Mountains in China, Mount Hengshan of Shanxi Province is famous for its 18 scenic spots, especially the Xuankong Temple (the Suspended Temple).

Built in the Northern Wei Dynasty (386 - 534), Xuankong Temple faces a cliff at the waist of the Cuiping Peak. With dangerous rocks overhead and an abyss below, Xuankong Temple really seems to be suspended in mid-air.

Mount Hengshan is close to Mount Wutai, and a tour of both famous mountains is a common choice.

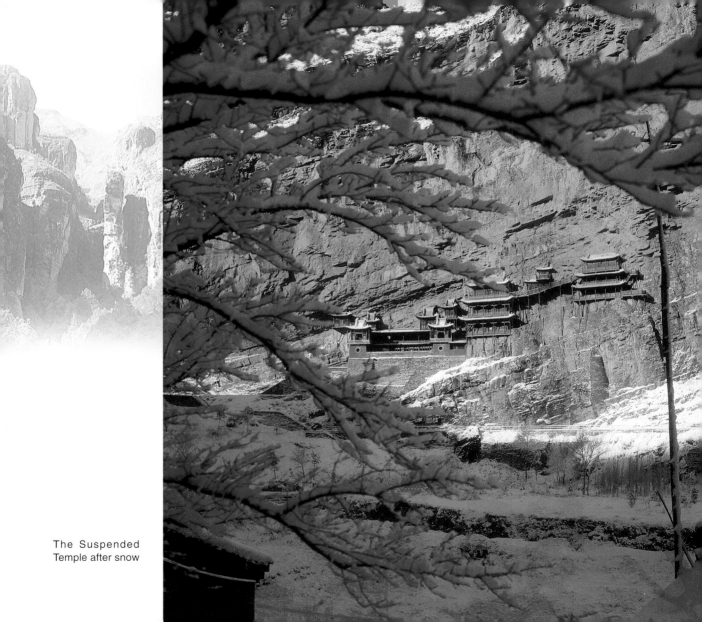

The Suspended
Temple after snow

The temples of Mount Wutai

# Mount Wutai

As one of the four well-known Buddhist mountains in China, Mount Wutai is situated in Wutai County, Shanxi Province. In the Eastern Han Dynasty (25-220 A.D.), people started to build temples in mountainous areas of today's Wutai County. There are now a total of 76 temples on the mountain, ranking first in China. Temple construction has not stopped during the past 1,900 years. Some call it the Temple Village. Missing one or two temples is to be expected, even after visiting them one by one.

The landmark of Mount Wutai is the Nepalese-style Great White Tibetan Pagoda, with a base circumference of 83.3 m and a height of 75.3 m. Inside the pagoda, there is a small iron stupa from India, where some remains of Sakyamuni are kept.

Numerous temples on Mount Wutai have many different relics and other unique attributes, such as the 1200-year-old Nanchan Temple, which is the best-preserved, earliest wood-structure temple still surviving.

Mount Wutai is also an excellent choice for a summer resort. Its climate is cool throughout the whole summer, and it attracts large numbers of people seeking cool weather and religious cultivation.

The stone gateway of Longquan Temple ▶

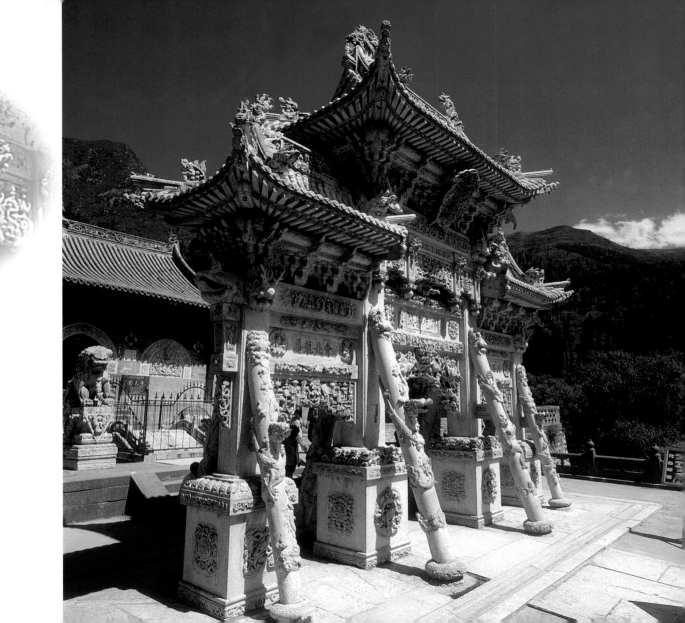

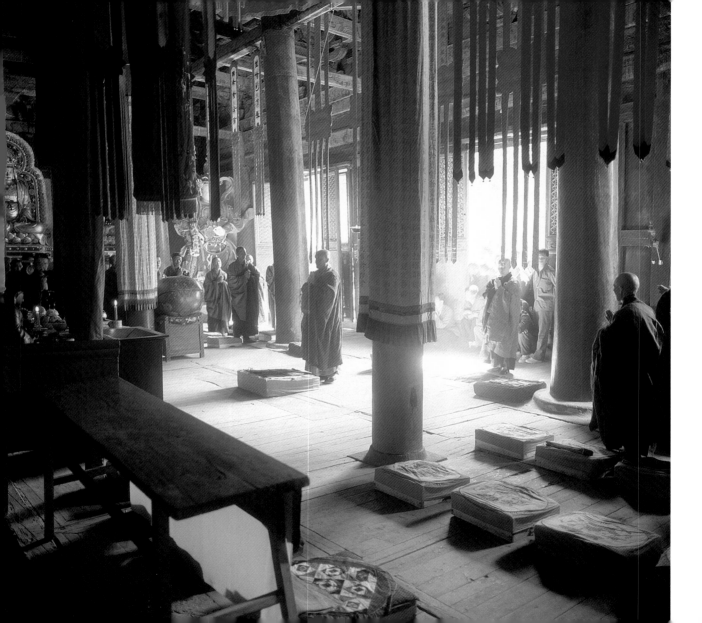

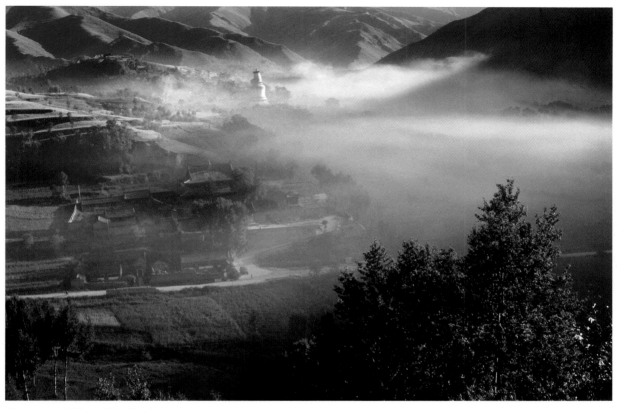

A landmark of Mount Wutai —the pagoda for Buddhist relics

◄ Inside view of a temple

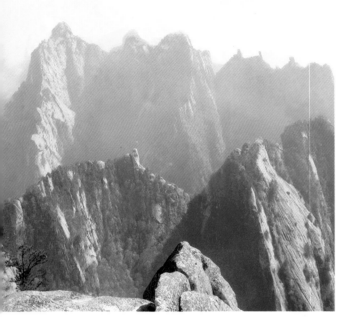

Wulao Peak

Mount Huashan enveloped ▶
by a sea of clouds

attraction for many, including emperors, public officials, scholars, and Taoists. The historical and cultural legacies left by those people complement Mount Huashan's natural beauty.

Mount Huashan is a preferred spot for Taoist cultivation and *gongfu* practice, and it is also the choice of those seeking enjoyment in great mountains.

# Mount Huashan

Mount Huashan is the most difficult of the Five Great Mountains in China to climb. Situated in the eastern part of Shaanxi Province, with an elevation of 2,200 m above sea level, Mount Huashan is noted for its dangerous and precipitous peaks. The saying is true that "Since ancient times, there is only one road to the summit of Huashan," Mount Huashan is the best choice for visitors who like the challenge of mountain climbing. The higher one climbs, the more magnificent the view and higher one's spirits are lifted.

With peaks soaring to the sky, cliff-like slopes and enchanting natural beauty, Mount Huashan is a favorite

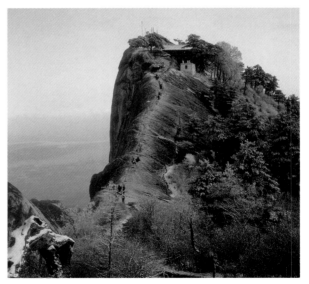

Precipitous West Peak

30

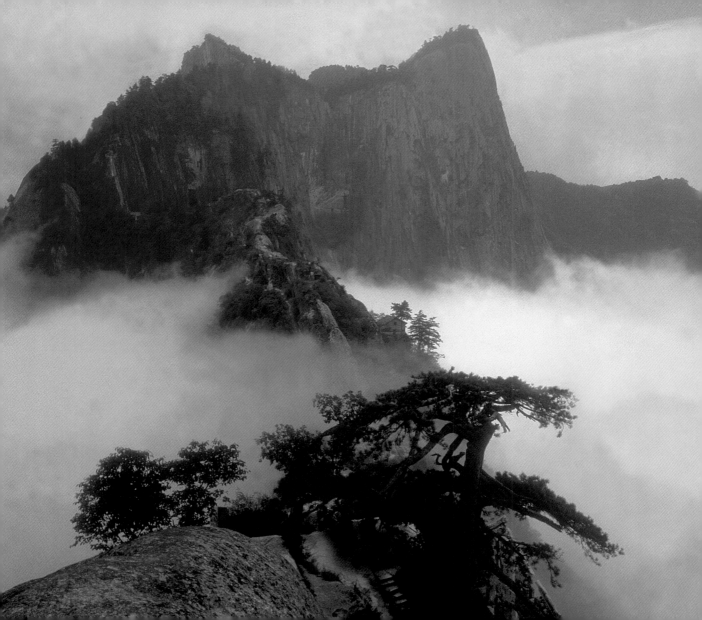

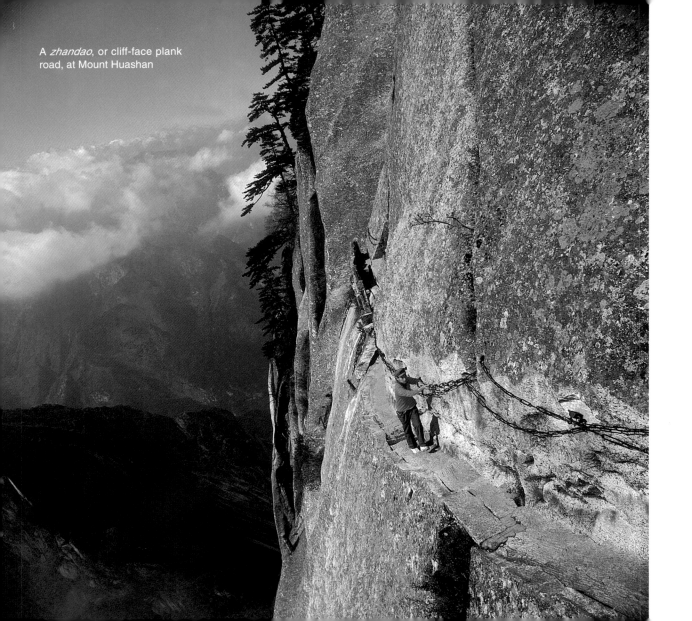

A *zhandao*, or cliff-face plank road, at Mount Huashan

# Mount Songshan

From Bruce Lee to Jet Li, from *Crouching Tiger, Hidden Dragon* to *Rush Hour*, if you admire true Chinese *gongfu*, you should not miss the epicenter of Chinese *gongfu* when visiting China—Shaolin Temple at Mount Songshan.

Located in the northwest of Dengfeng County, Henan Province, Mount Songshan is one of the Five Great Mountains in China. As magnificent and beautiful as the other famous mountains in China, Mount Songshan is also noted for its reputation as the Mecca of Chinese *gongfu*, because of its association with Shaolin Temple.

Looking up Mount Songshan

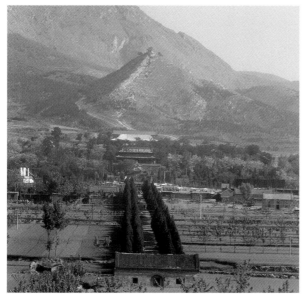

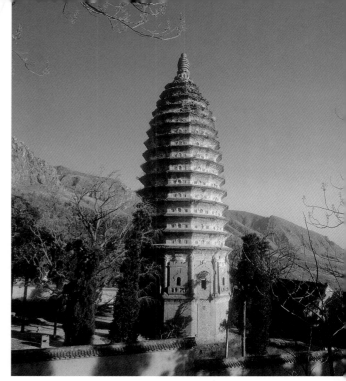

The Songshan Temple Pagoda, the oldest extant brick Buddhist pagoda in China

Built in 495, Shaolin Temple boasts a long martial arts tradition stretching back to the Tang Dynasty. The fresh air and beautiful scenery of Mount Songshan provides the best practice site for masters of Chinese *gongfu*.

To visit Mount Songshan is to kill two birds with one stone: enjoying the beauty of a great mountain on the one hand, and on the other, paying homage to true Chinese *gongfu*.

Shaolin Temple

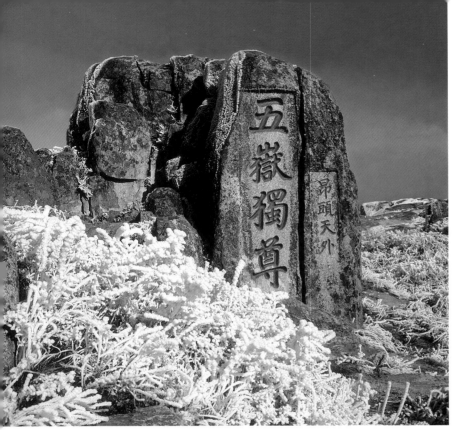

First of the Five Great Mountains, the rock monument commemorates Mount Tai as the foremost of the Five Great Mountains.

tion of 1,545 m at its highest peak, but because of its magnificent scenery, including the sunrise, the sunset, seas of clouds, the Buddha's halo and frost-covered plants and most important, because it was the holiest and most important mountain in the eyes of the ancient Chinese, especially the emperors and famous people. In the 2000-plus years from the Qin Dynasty (221-206 B.C.) to the Qing Dynasty (1644-1911), more than ten emperors went to Mount Taishan to personally make sacrifices to Heaven. At the same time, Mount Taishan became a holy site for Taoists, Buddhists, and Confucians. Another unique attraction of Mount Taishan is enjoying the poems and calligraphy left by ancient sages and scholars. As one famous ancient poet exclaimed, "When towering aloft on the highest peak, one sees how small all the other mountains are."

## Mount Taishan

If you can visit only one of China's great mountains, you should visit Mount Taishan, located in Tai'an City, Shandong Province. Mount Taishan is the "First Mountain Under Heaven" among the Five Great Mountains of the ancient Chinese, not because of its total area of 426 sq km or eleva-

Azure Cloud Temple was built in the Song Dynasty ▶ in honor of the Supreme Lord of the Azure Cloud. The temple is a magnificent architectural unit from ancient times on the summit.

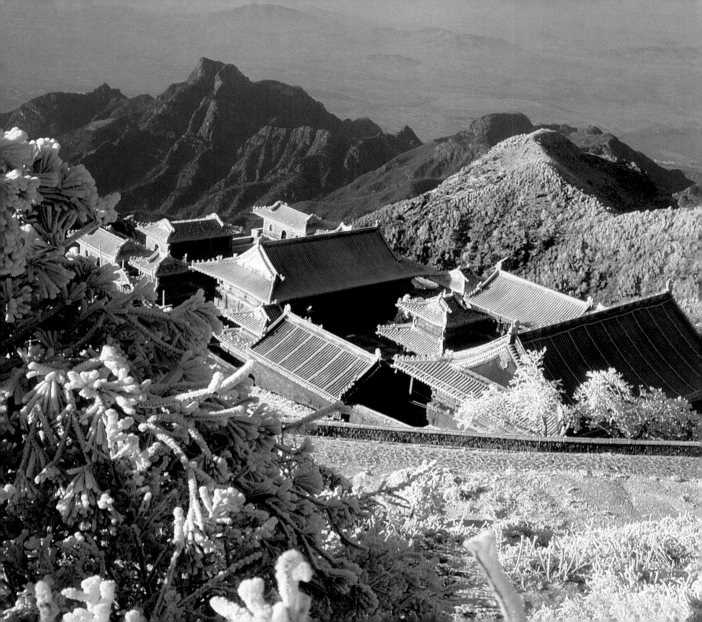

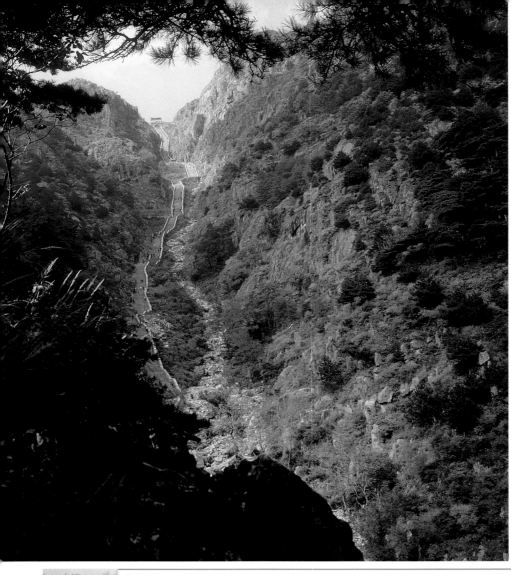

The Eighteen Mountain
Bends, the main road for
climbing Mount Tai

# The Songhua River

The largest branch of the Heilong River, Songhua River is 1,840 km long and has a drainage area of 540,000 sq km. The Songhua River valley is densely covered by mountains and virgin forests and is the largest forest region in China. The Songhua River basin's fertile land makes it abundant in beans, corn, Chinese sorghum, wheat, and other agricultural products. In addition, the Songhua River is rich in mineral resources and has one of northeast China's major freshwater fish farms.

The Songhua River is cold in winter and is frozen for five months out of the year. But the stretch at the Fengman Hydro-electric Power Station is an exception. Because water exiting the station is higher in temperature, steam rising from the river forms clusters of ice flowers on the tree branches and leaves along the river. For 10 km, there is a world of beautiful ice creations. The Songhua River is famous for its scenery of frost-covered plants.

A cruise on the rippling Songhua Lake

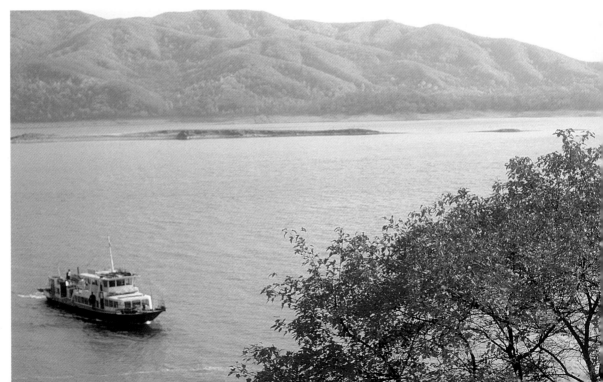

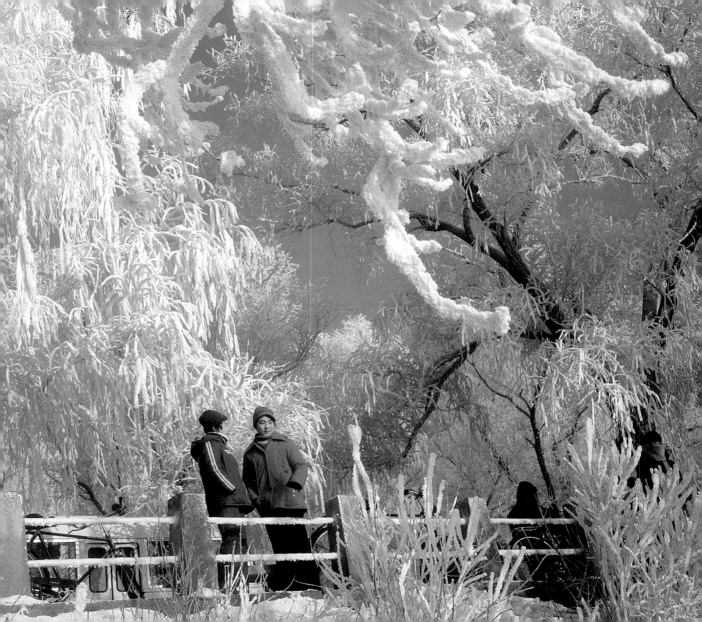

# Mount Changbai

Located in the south of Jilin Province, Mount Changbai is noted for its sea of forests and Heavenly Pond. The natural landscapes of Mount Changbai are particularly well preserved because it has been rarely visited for the past thousand years. The beauty of Mount Changbai lies in its fantasy-like natural beauty. The towering peaks, vast expanses of forests, rippling blue ponds, scattered springs, and rich resources including the three treasures of northeast China (ginseng, pilose deer-horn, and mink) have attracted ever-increasing numbers of people. Mount Changbai is the birthplace of the Manchus, the ethnic group of the last feudal dynasty in China, the Qing Dynasty. Chinese history buffs may be particularly interested in more than its green slopes and blue waters.

Mount Changbai Natural Reserve under a blue sky with white clouds

◀ Beautiful frost-covered trees

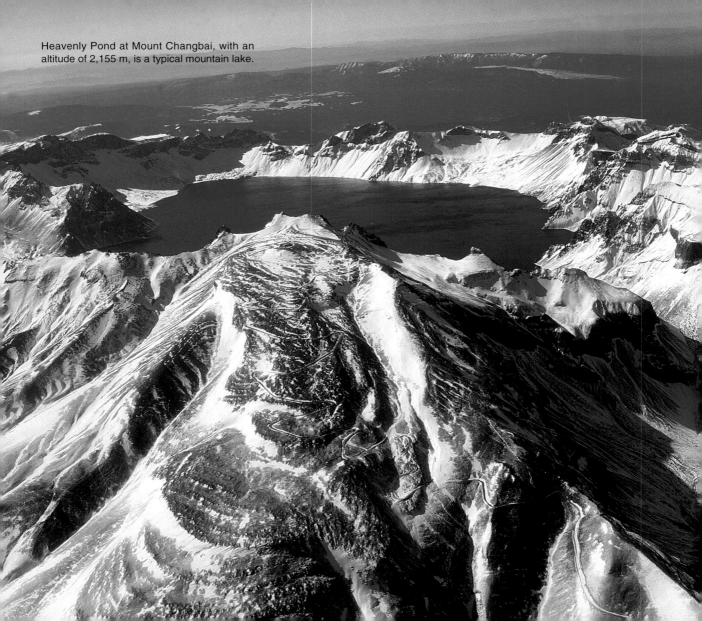

Heavenly Pond at Mount Changbai, with an altitude of 2,155 m, is a typical mountain lake.

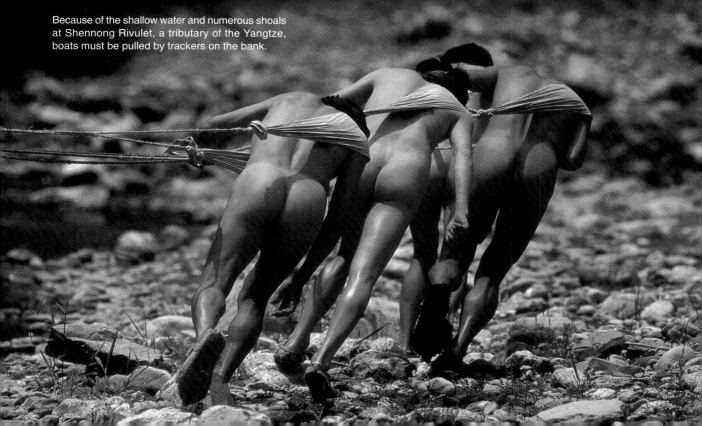

The Yangtze River is the longest in China. Upstream, its current is swift, with perilously beautiful gorges; downstream is a land of plenty crisscrossed by a network of rivers. On both sides of the Yangtze River, the mountains and water are charming, and the bamboo fences and huts exude a quiet elegance: each bit of scenery looks like a painting.

Because of the shallow water and numerous shoals at Shennong Rivulet, a tributary of the Yangtze, boats must be pulled by trackers on the bank.

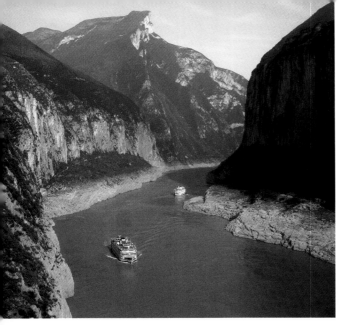

Kuimen of the Three Gorges on the Yangtze River is famous for its rugged grandeur. At its entrance, cliffs stand on both sides, with a width of no more than 100 m.

# The Yangtze River

The Yangtze River, the longest river in China and third-longest in the world, is the mother river of the people of central and southeast China. Originating in the Tanggula Mountains of Qinghai Province, the Yangtze River winds from northwest to southeast, with a total length of 6,300 km. Its main channel passes through Qinghai, Tibet, Sichuan, Yunnan, Hubei, Hunan, Jiangxi, Anhui, Jiangsu and Shanghai, finally emptying into the Pacific Ocean at Chongming Island.

With several thousand tributaries, the Yangtze River valley covers an area of more than 1,800,000 sq km, including 185 cities. Each part of the Yangtze River has a different type of scenery: in the upper reaches of the river from Jiangyuan to Yichang, one can observe many precipitous mountains, including the world-famous Three Gorges and the would-be largest dam in the world over it; in the middle reaches of the river from Yichang to Hukou, the Yangtze River zigzags through Hubei, Hunan and Jiangxi with many branches and lakes; in its lower reaches from Hukou to the estuary, the Yangtze River becomes smooth and wide.

From the source to the estuary, you can enjoy different breath-taking scenes on the mighty Yangtze River.

A restored plank road along a cliff of the Daning River. A tributary of the Yangtze, the Daning River meets it at the western mouth of the Wu Gorge.

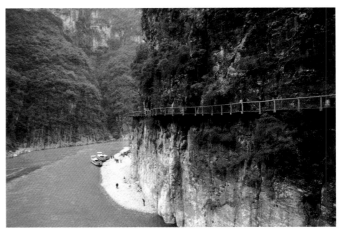

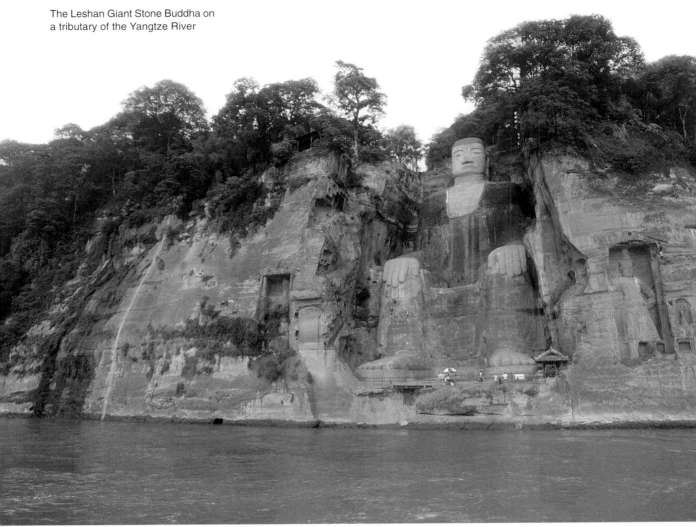

The Leshan Giant Stone Buddha on a tributary of the Yangtze River

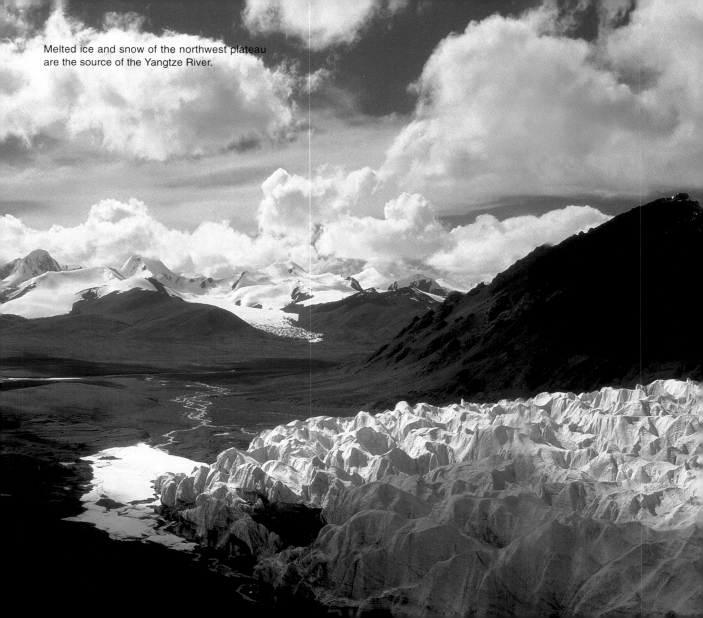

Melted ice and snow of the northwest plateau
are the source of the Yangtze River.

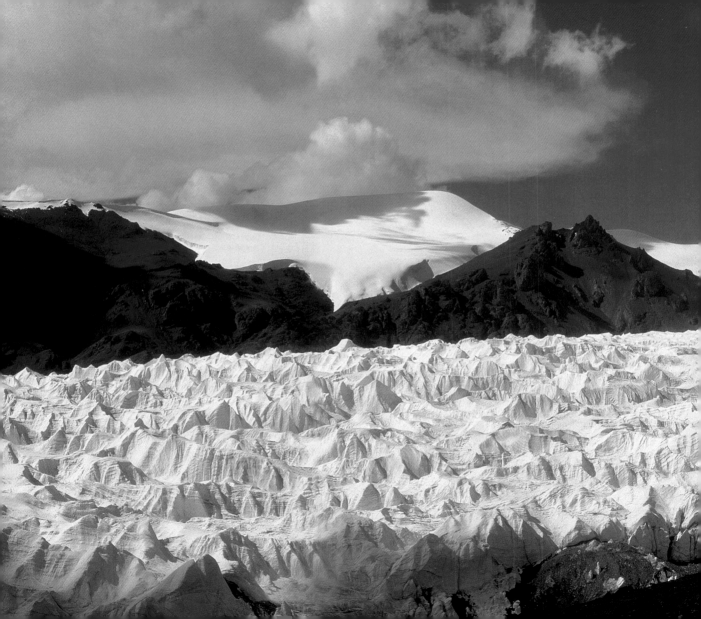

The middle reaches of the Yangtze River pass by
Yellow Crane Tower in Wuhan, Hubei Province

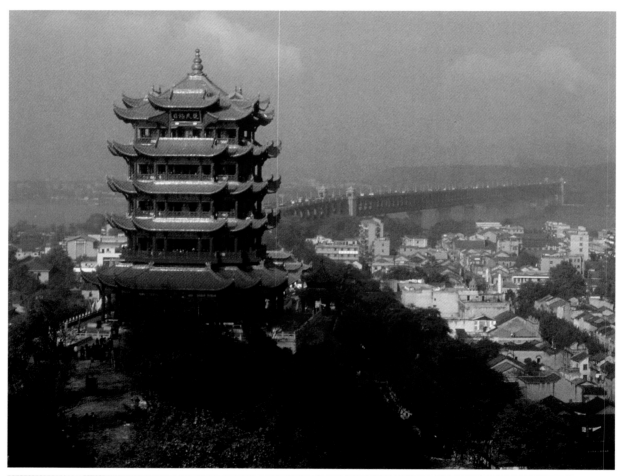

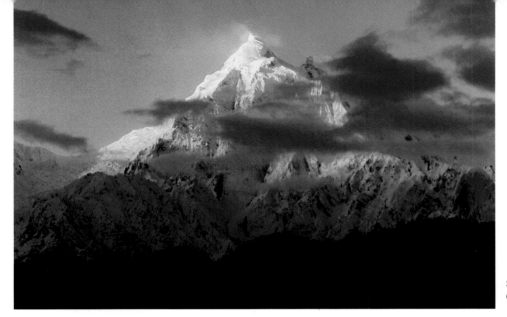

Snow-caped
Gyarapel Peak

# The Yarlung Zangbo River

The Yarlung Zangbo River is an international river. It flows through China for 2,057 km, fifth place among China's rivers. Its source is at the northern slope of the Himalayas, and the Yarlung Zangbo River flows through many counties of Tibet. In most parts, its bed is more than 3,000 m above sea level, making it the highest river in the world. The shores of the river have peaks soaring to the clouds and lush virgin forests. The world-famous Yarlung Zangbo Great Canyon, which has been authenticated as the largest canyon in the world with a depth of 5,382 m, boasts unique and magnificent natural scenery.

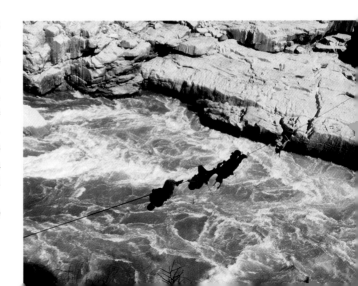

Explorers crossing the
Yarlung Zangbo River

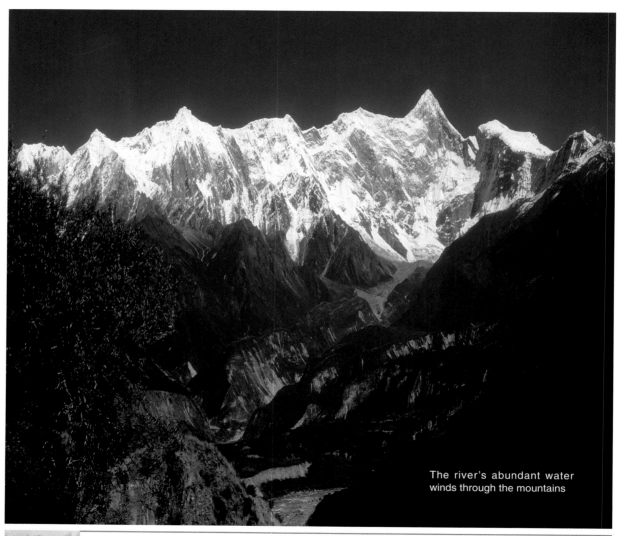

The river's abundant water
winds through the mountains

The Great Canyon of the Yarlung Zangbo River

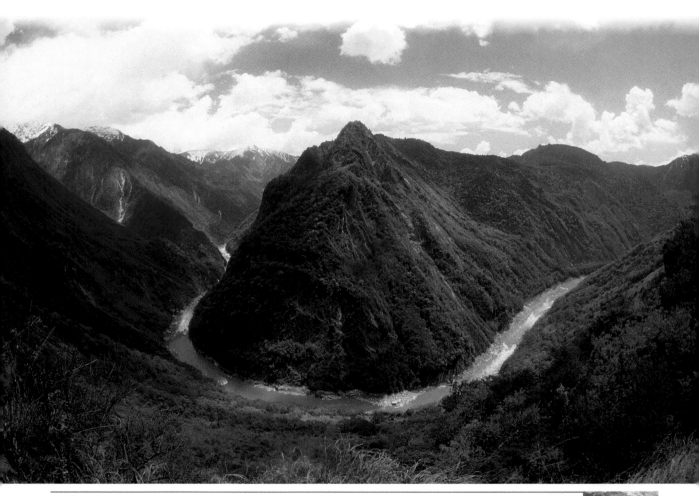

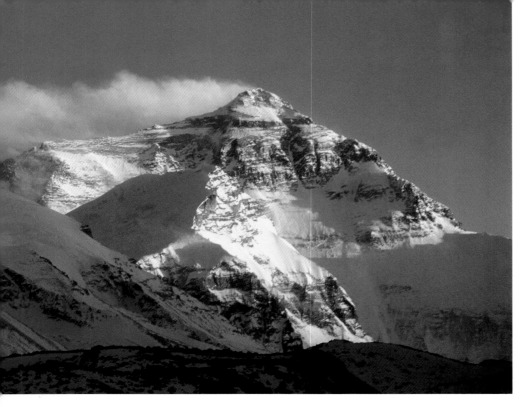

The highest peak in the world—Mount Everest

A glacier in the ▶ Himalayas

## The Himalayas and Mount Everest

Located at the southern edge of the Qinghai-Tibet Plateau, the Himalayas are the world's highest and mightiest mountains. The Himalayas' peaks have an average altitude of 6,200 m, and the highest peak in the world—Mount Everest, in the middle of the Himalayas—with an altitude of 8,848.13 m, is the peak that the whole world's mountain climbers most want to conquer. The holy and pure ice and snow on Mount Everest haven't melted for thousands of years. The world-famous 20-odd-kilomter long Rongbo Glacier and the rarely seen beautiful ice forests can also be found here. Near Mount Everest, there are more than 40 mountains with peaks at least 7,000 m above sea level.

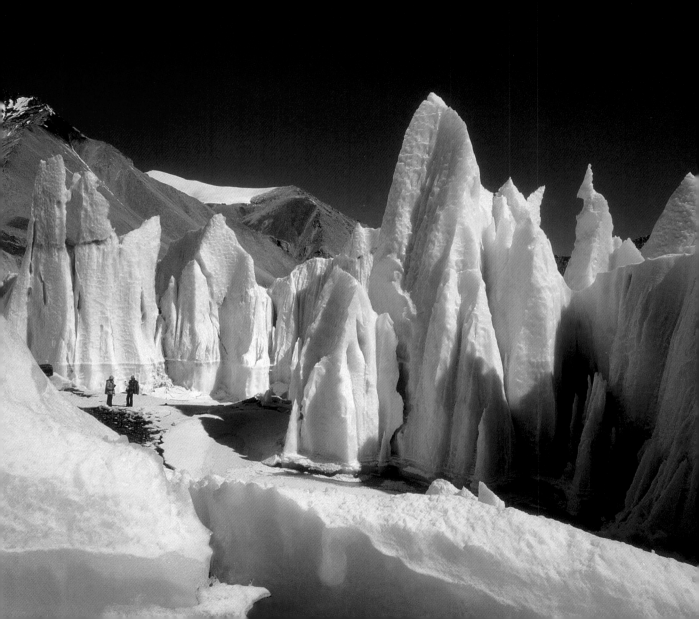

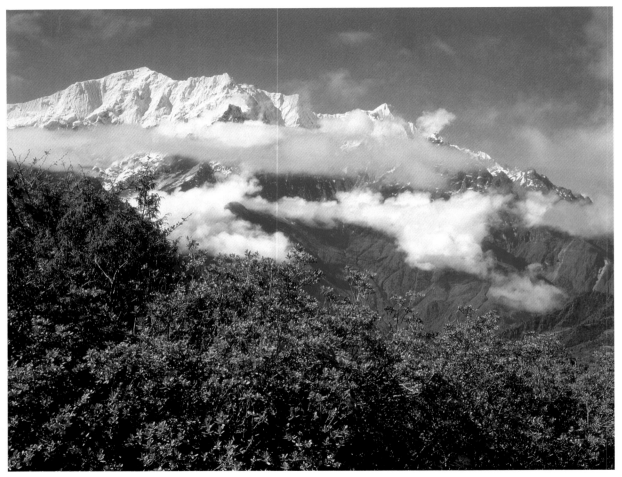

A green section of the Himalayas

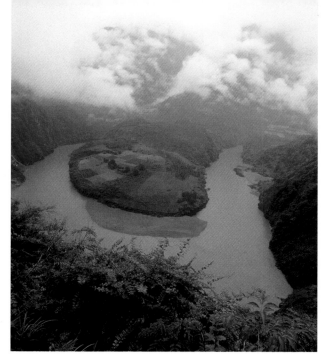

The first bend of the Nujiang River

# The Nujiang River

Originating in the southern part of the Tanggula Mountains, Tibet Autonomous Region, the Nujiang River flows into Yunnan at Gongshan County. From north to south between Mount Nushan and Mount Gaoligong, its 2816-kilometer-long main stream goes through Fugong, Bijiang, Lushui, Baoshan, Shidian, Longling, Yongde and Zhenkang counties. The Nujiang River flows out of China to Burma (where it is called the Salween River) at Luxi County.

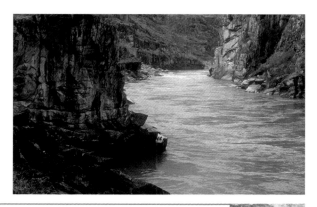

The Nujiang River valley

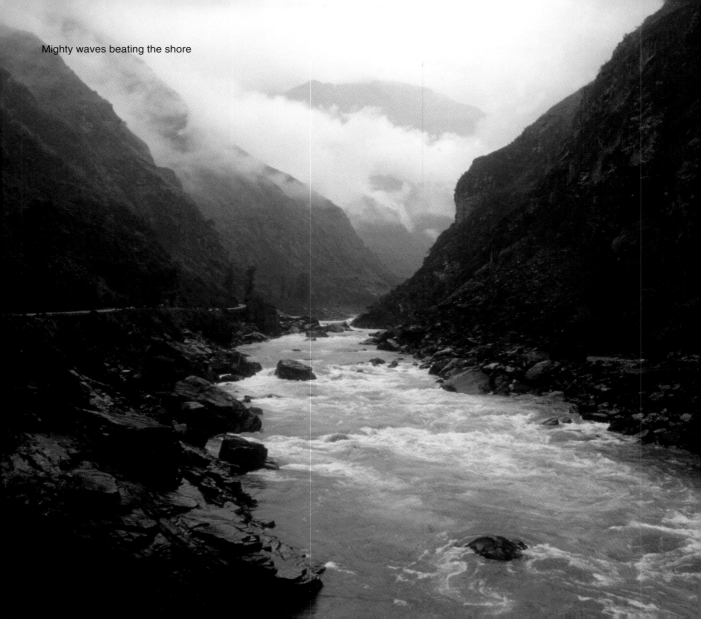

Mighty waves beating the shore

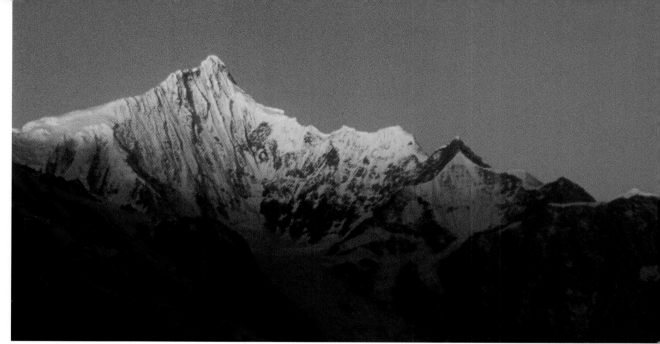

Snow-capped Meili Mountain

# Shangri-la

Westerners know the mythical land of Shangri-la from James Hilton's best seller *Lost Horizon*, while the Tibetan people living on Diqing Plateau of Yunnan Province know the term Shangri-la from their ancestors. In the Tibetan language, Shangri-la means "sun and moon in the heart." Some may say that the Shangri-la of Diqing Plateau is not the same as the one in Hilton's novel, but nobody can doubt its incomparable beauty and mystery.

Diqing, an area in northwest Yunnan Province surrounded by snow-capped mountains with difficult communication, is perhaps the most mysterious land in China. Featuring numerous deep gullies, spiky snow-covered peaks, and rolling meadows for grazing herds, it is impossible to see a flat horizon there. Amid endless natural beauty—the blue sky, the red sun, dense forest, limpid rivers and lakes, lush grasslands, snow-capped mountains, and rare animals including the golden monkey and the lesser panda—the Tibetan people, along with other ethnic groups, such as the Naxi, Yi, Bai, Hui, Pumi and Lisu, live a peaceful life in a true haven of peace.

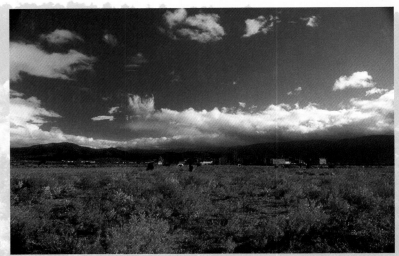

Autumn in a small grazing pasture in Zhongdian

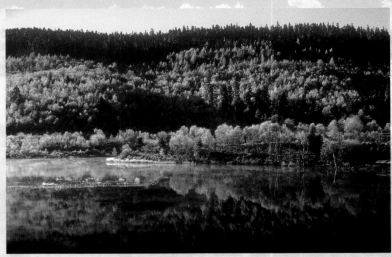

The quiet Lake Shudu

The wetland of Lake Napa, an ideal habitat
for black-necked cranes in winter

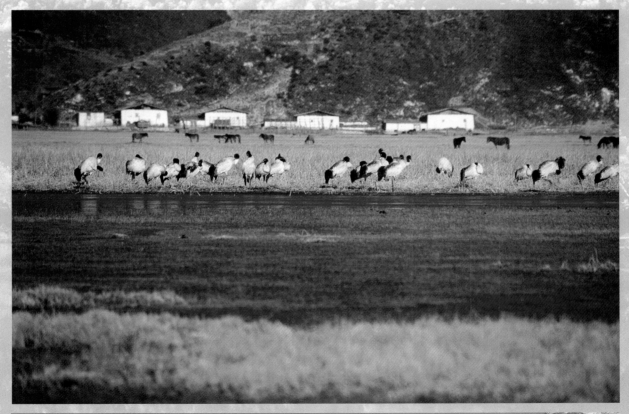

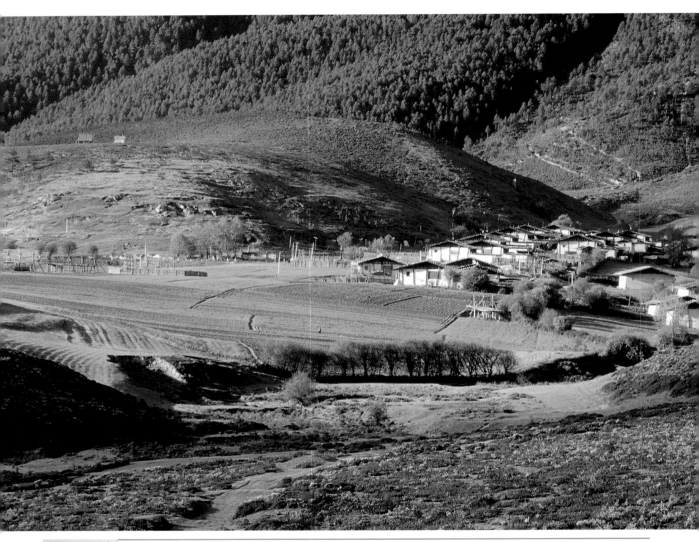

60

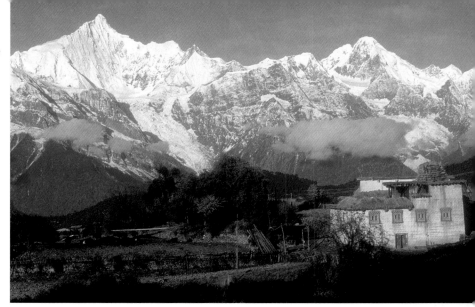

Tibetans living by the holy mountain

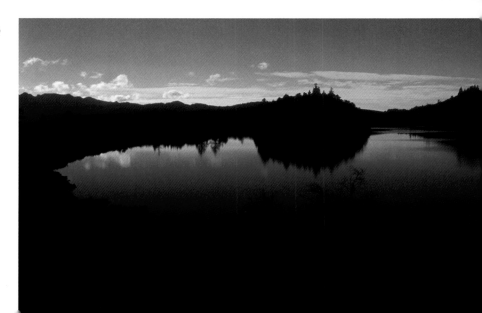

Lake Nirunabo

Shangri-la in spring

The largest Tibetan Buddhist Monastery in
Yunnan Province—Gandan Songtsanling

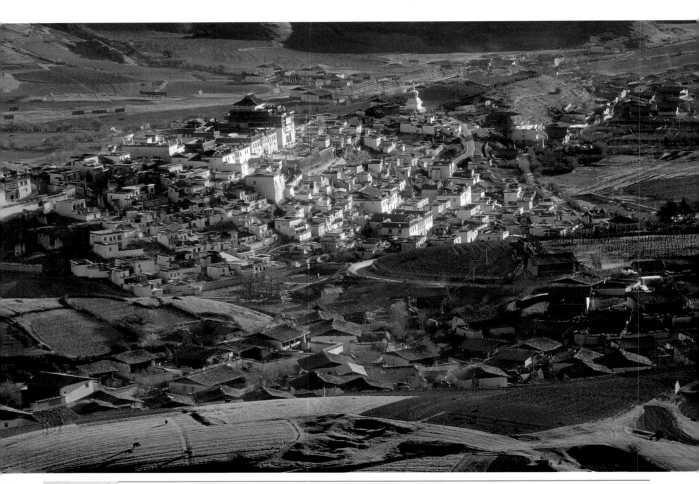

62

# Jiuzhaigou (Jiuzhai Valley)

The scenic area of Jiuzhaigou is located in Nanping County of Tibetan and Qiang Autonomous Prefecture, Sichuan Province. Its primary scenic areas comprise 50 sq km at an average altitude of 1,800 m above sea level. The terrain slowly slopes from north to south. Famous for its beautiful scenery, Jiuzhaigou is considered the best in China for its mountain lakes and waterfalls. In Jiuzhaigou, you can find natural beauty, such as streams, waterfalls, snow-capped peaks, forests and travertine shoals, as well as the charm of the Tibetan people and their customs. You take in your fill of the blue sky and water and birds singing sweetly in the highly forested Jiuzhaigou.

Pearl Floodplain

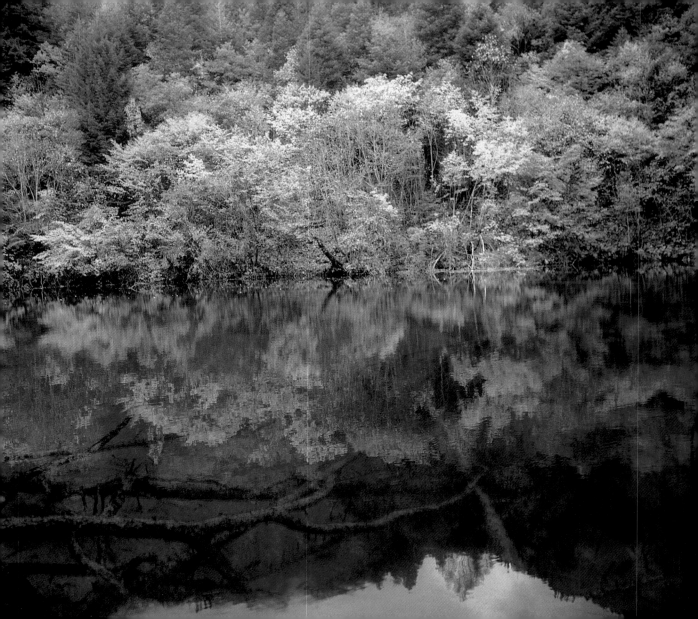

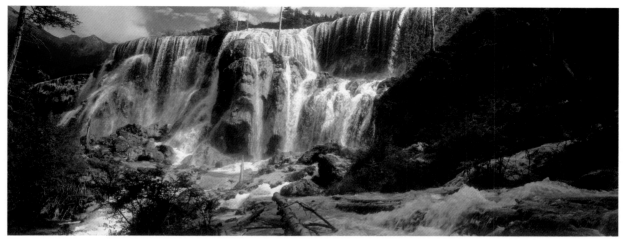

Waterfalls of
Jiuzhaigou

◄ Five-Color Lake

Five-Color Sea

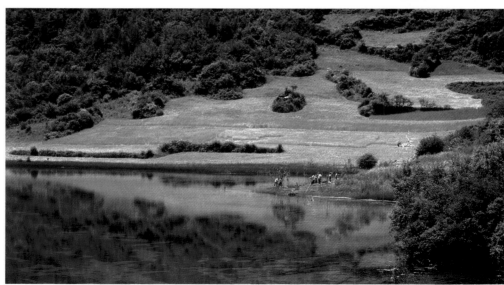

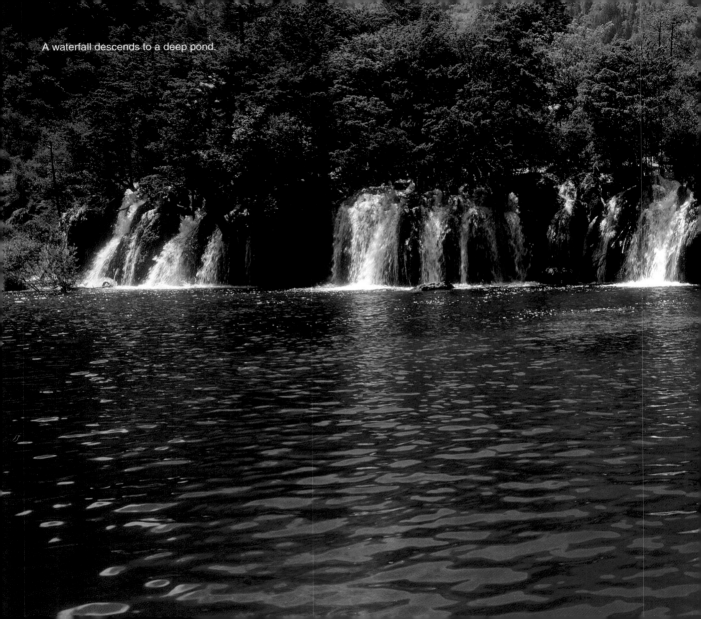
A waterfall descends to a deep pond.

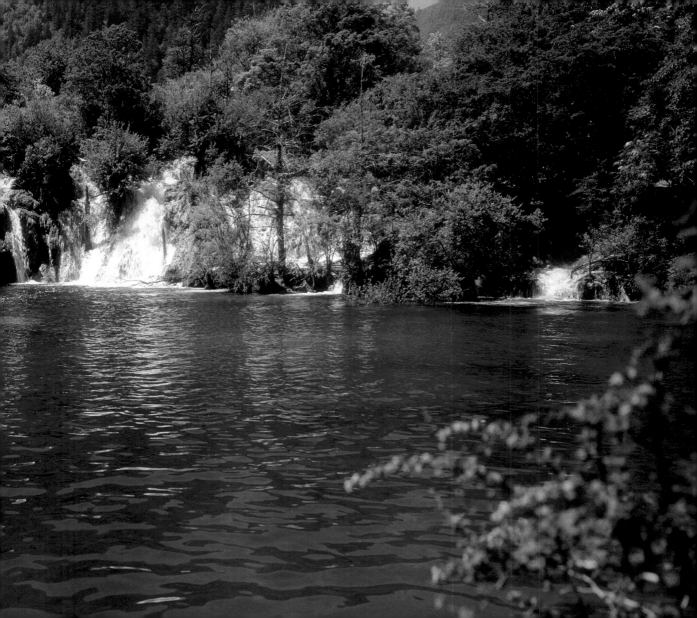

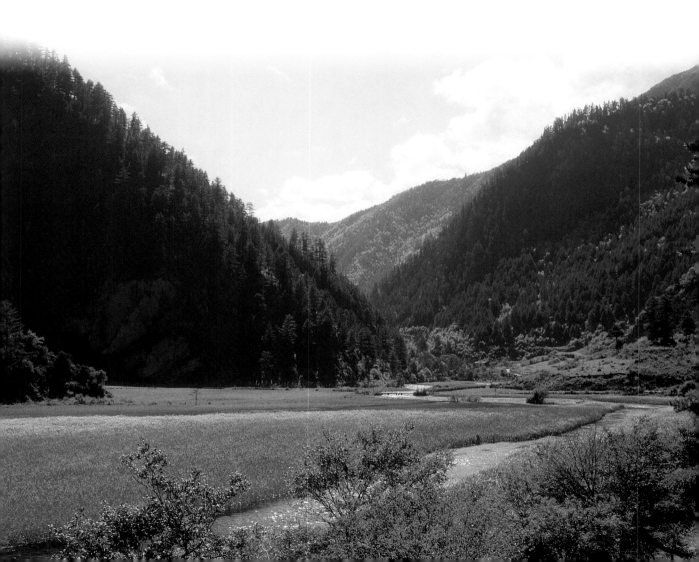

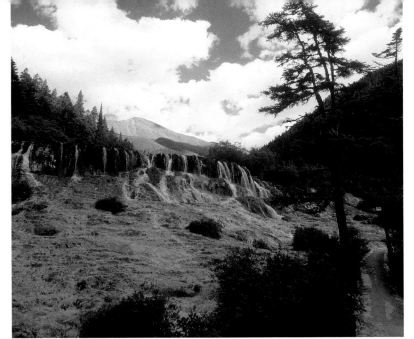
Waterfalls splashing in the air

# Huanglong

Situated to the south of Mount Minshan, in Songpan County, northern Sichuan Province, Huanglong Scenic Area encompasses 700 sq km at an altitude of 3,000 m above sea level, featuring a great number of snow-capped peaks. Huanglong has a unique landscape, as well as terrain, geomorphology, and well-preserved eco-logical resources. In Huanglong, you can find scenery resembling other countries, such as Canada's snowy mountains, Wyoming's valleys, Colorado's ancient forests, and Yellowstone Park's multicol-ored ponds. The landscapes of Huanglong is uniquely vast in scale, exquisite in structure, and rich in color.

Multicolored ponds

◀ Lake Reed

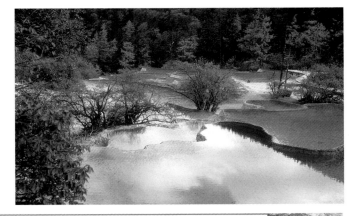

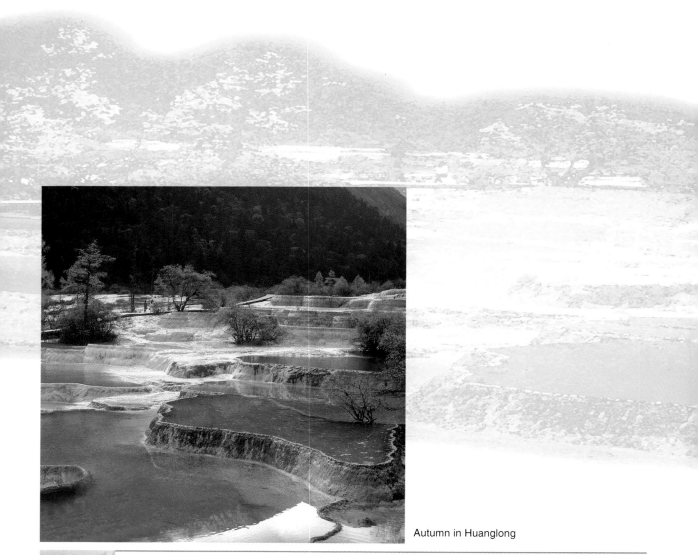

Autumn in Huanglong

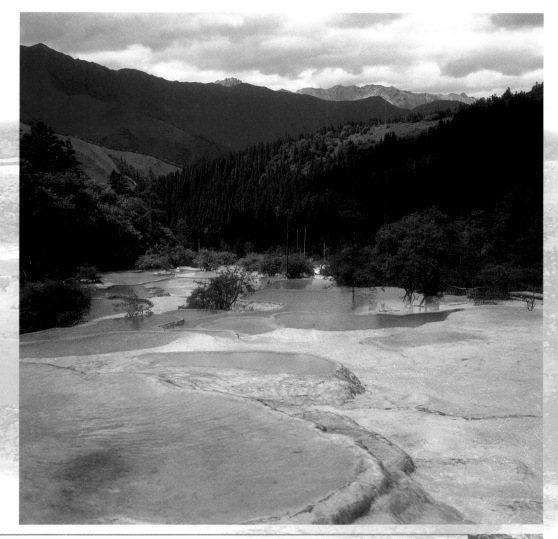

Lush forests

# Mount Qingcheng

Mount Qingcheng, meaning "Green Town" in Chinese, is noted for its ancient trees. Located in the Dujiangyan scenic spot of Chengdu, Sichuan Province, Mount Qingcheng is one of the four famous Taoist mountains. Surrounded by countless peaks and densely covered with ancient trees, branches reaching the sky, Mount Qingcheng is called the quietest place under heaven. That may be the reason that Taoists in ancient times chose Mount Qingcheng to cultivate their spirits.

Mount Qingcheng is divided into two parts, a front and a rear area. The former is noted for its beautiful scenery and numerous cultural and historic sites; the latter, for its mysterious views.

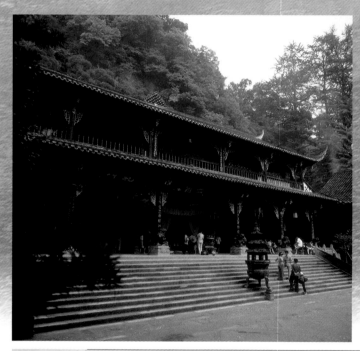

Shangqing Temple, located at the summit of Mount Qingcheng, a prime spot for viewing the scenery

Mount Qingcheng: the quietest and most remote mountain under heaven

A screen wall inscribed with the words, "THE mountain under heaven."

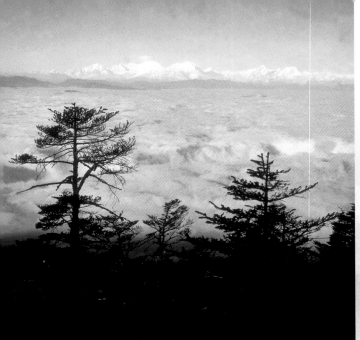

Looking into the distant Gongga Mountains

Baoguo Monastery

# Mount Emei

Located in Sichuan Province, 156 km away from Chengdu (the capital city of Sichuan), Mount Emei, dedicated to Manjusri, the Bodhisattva of Universal Kindness, is one of the four great Buddhist mountains in China.

Known as "the most beautiful mountain under heaven," Mount Emei is famous for breathtaking views and its still flourishing temples, such as the Pavilion of the Clear Singing Waters and Baoguo Monastery.

With an elevation above the Five Great Mountains in China, Mount Emei boasts both grandeur and loveliness. It is said that Mount Emei has different seasons and weather in different areas at the same time.

Along with the monks living in the temples, a large number of monkeys are residents of Mount Emei. On the road to the summit, many monkey beggars ask travelers for food.

74

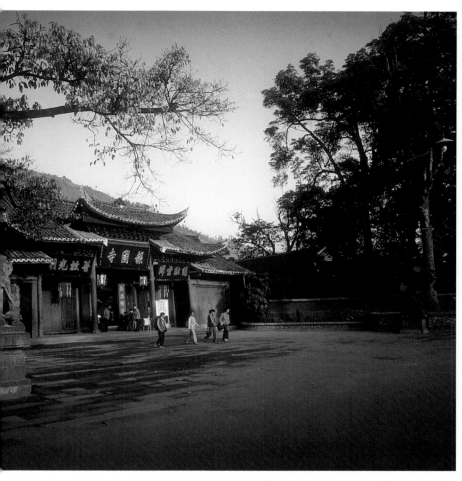

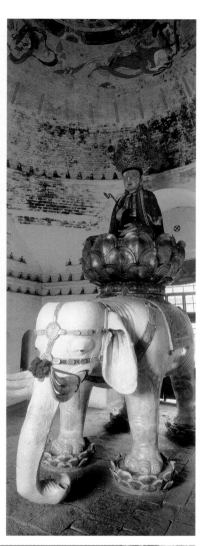

The bronze image of Manjusri, the Bodhisattva of Universal Kindness, in the Temple of Wannian, built in Song Dynasty

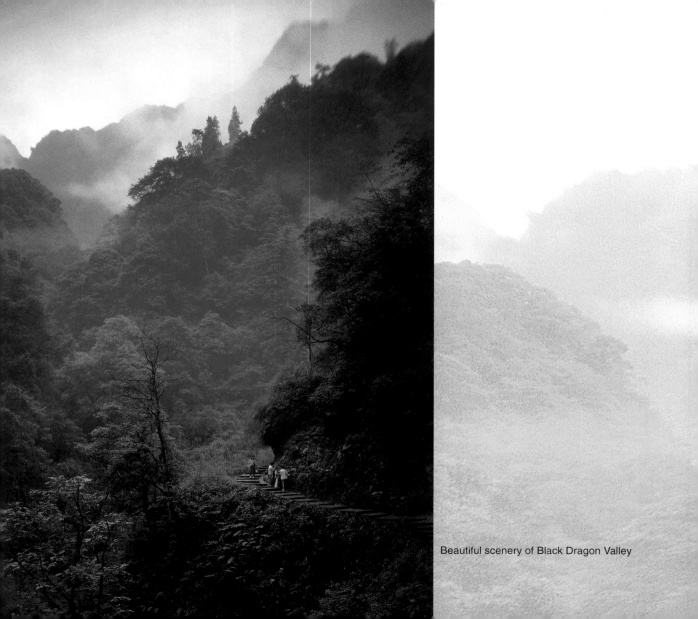

Beautiful scenery of Black Dragon Valley

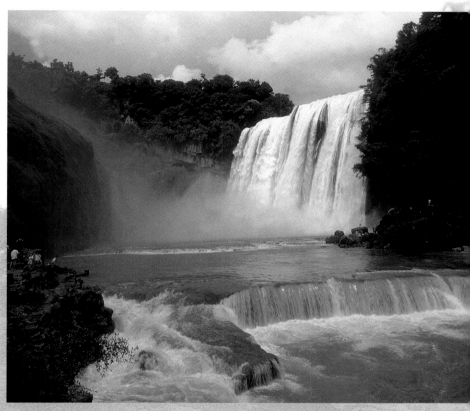

A waterfall pouring down
from a great height

## The Huangguoshu Waterfall

The Huangguoshu Waterfall, one of the largest in China, is situated on the Baishui River, 15 km southwest of Zhenning Bouyei-Miao Autonomous County. The bed of the Baishui River is like a staircase descending step by step, with nine falls, of which the Huangguoshu Waterfall is the largest. The Huangguoshu Waterfall is 30 m wide, sometimes as wide as 40 m in the rainy season. As the river pours down from a height of more than 68 m, it sends out spray 100 m wide, which glitters like a rainbow in the sunlight. The roaring waterfall is full of power and grandeur.

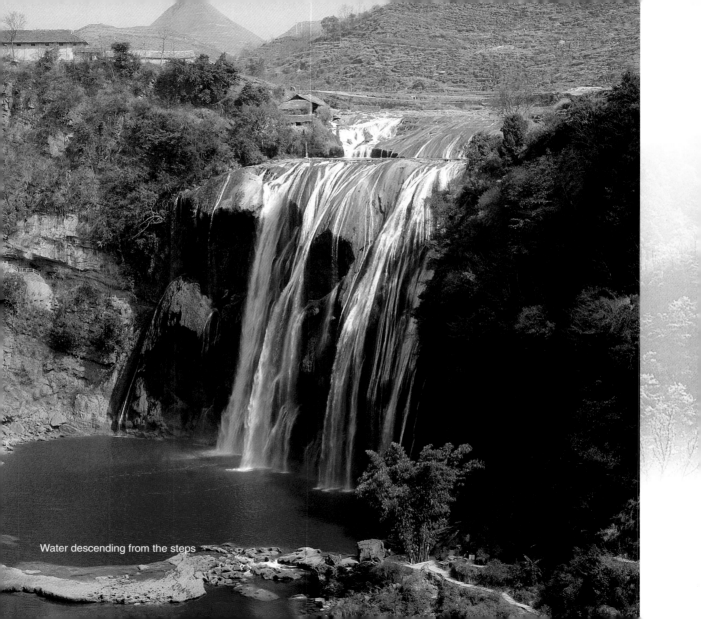

Water descending from the steps

A bird's eye view of Mount Wudang's ancient buildings from the Golden Peak

# Mount Wudang

Mount Wudang, also called Mount Taihe, is located in Danjiangkou City, Hubei Province, and its highest peak, Tianzhu, is 1,612 m above sea level. Since ancient times, Mount Wudang has been called "The number one immortal mountain under heaven," not only for its fantastic scenery, but also for its status as the holy land of Taoism since the Tang Dynasty and the center of China's Taoist community. For this reason, Mount Wudang possesses many ancient, large scale Taoist buildings. These beautifully decorated buildings, with their strictly-regulated internal structure, make them one of a kind in China and the world. Wudang *gongfu* is one of the most important schools of China's *wushu* (martial arts). Just as UNESCO describes, Mount Wudang blends ancient wisdom, historic buildings and natural beauty into one; China's great history is still alive at Mount Wudang.

Beautiful scenery at Mount Wudang

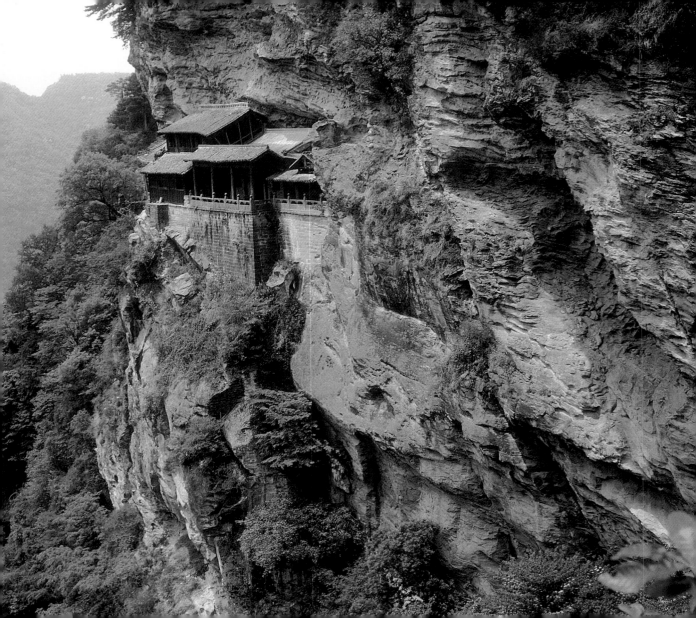

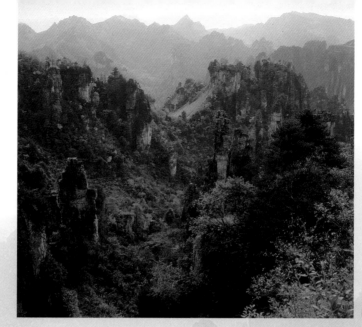

◀ Nanyan Palace, built on a cliff

Early fall in Wulingyuan

# Wulingyuan

Situated in western Hunan Province, about 400 km away from the provincial capital Changsha, Wulingyuan Scenic Area boasts more than 3,000 mountain peaks. For centuries, Wulingyuan remained unknown because of its remote location. Only in 1979 was this primitive land discovered; thus its natural environment is very well preserved. The beautiful scenery of Wulingyuan's quartz sand peaks is truly rare. The unique landscape of Wulingyuan, with its strange peaks and stones, deep valleys, beautiful streams, limestone caves and lush forests, has attracted both Chinese and foreign attention. In 1992, UNESCO named Wulingyuan to the World Heritage List.

Jinbian Rivulet

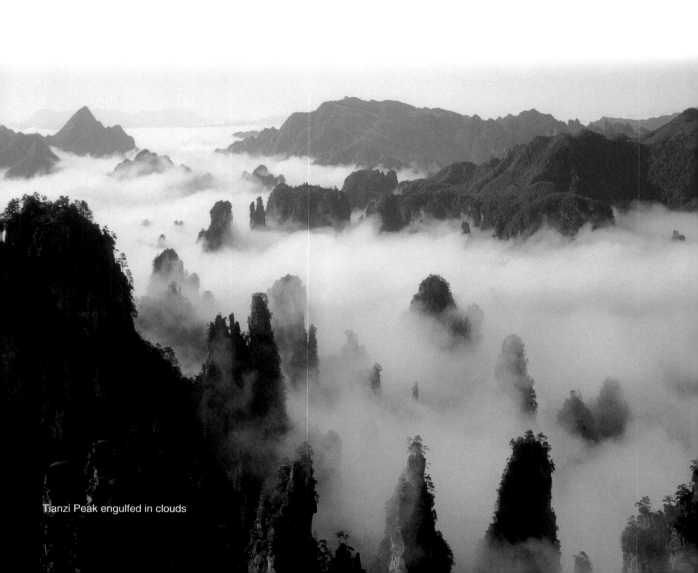
Tianzi Peak engulfed in clouds

A lush forest by a deep valley

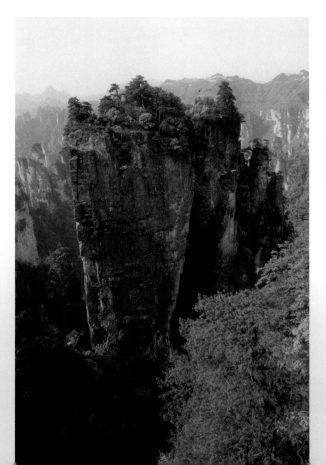

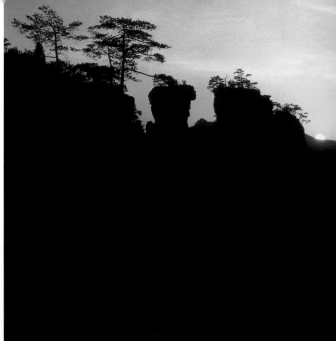

Shadow of trees at sunset

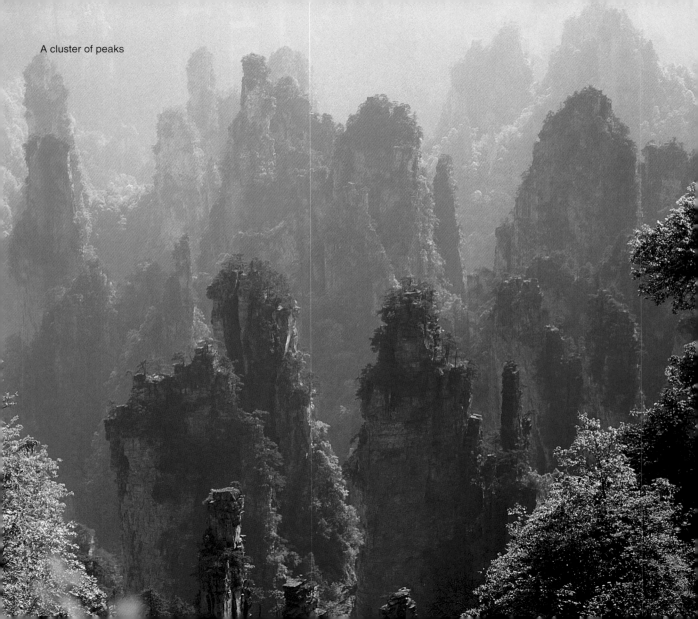

A cluster of peaks

# Mount Hengshan (Hunan)

Among China's Five Great Mountains, Mount Hengshan of southern Hunan Province is the Southern Great Mountain, with its principal peak rising 1,290 m above sea level. It boasts 72 lofty peaks and beautiful natural scenery. There are four principal scenic spots on Mount Hengshan, all of which have been given poetic nicknames: "Grandeur of the Zhurong Peak," "Charm of the Sutra Repository," "Wonder of the Waterfall Cave," and "Serenity of the Fangguang Temple."

Mount Hengshan was a hunting area and sacrificial site for emperors in ancient China as well as a religious site where both Taoists and Buddhists have long coexisted. It has attracted many famous poets, artists, statesmen, and other important figures in Chinese history.

Extending 400 km, Mount Hengshan, the "flying mountain," has different scenery in different seasons: flowers in spring, clouds in summer, the sunrise in autumn, and snow in winter.

Autumn scenery on Mount Hengshan

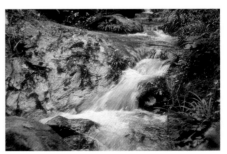

Dragon and Phoenix Brook

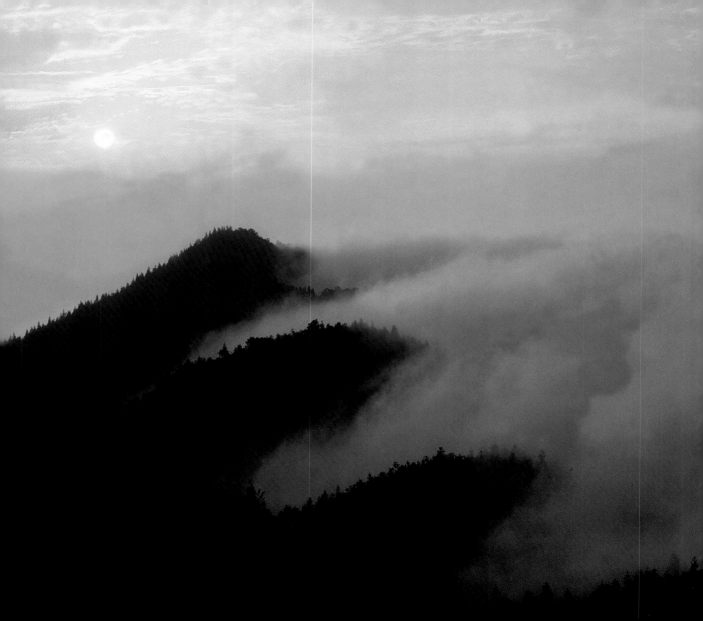

◀ Mount Hengshan en-
shrouded in clouds

Nanyue Temple

Ciping scenic area
at Mount Jinggang

## Mount Jinggang

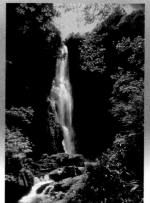

A waterfall descending into the
Dragon Pond

During the past several decades, Mount Jinggang was famous for its association with Chairman Mao. It was regarded as a revolutionary historic site rather than a scenic spot. In recent years, however, people have become more aware of the natural beauty of Mount Jinggang. It is worthy of being one of China's famous mountains in every aspect. Situated in a subtropical zone, Mount Jinggang has a mild and warm climate. With picturesque landscapes in all four seasons, Mount Jinggang is an especially good summer resort. Consisting of over 500 peaks both high and low, Mount Jinggang is a combination of grandeur, peril, beauty, quiet, and eccentricity. At the same time, its mountain rustic scenery is rarely seen in Chinese mountains. The verdant bamboo forests and clear mountain springs of Mount Jinggang are refreshing to the mind and spirit.

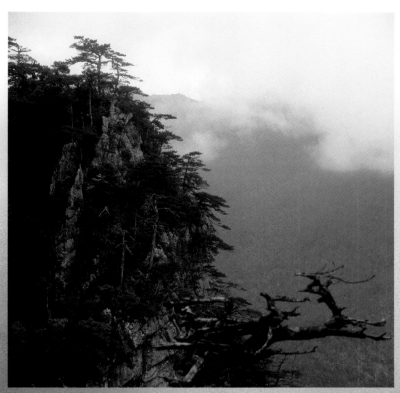

Deer Island of Mount Jinggang

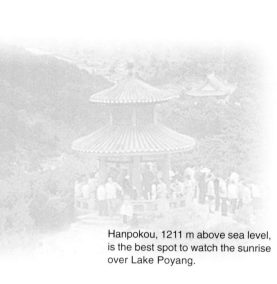

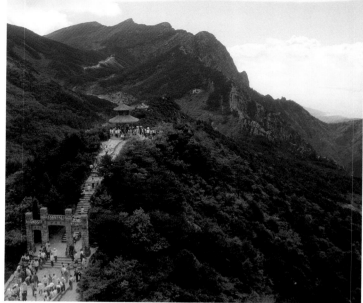

Hanpokou, 1211 m above sea level, is the best spot to watch the sunrise over Lake Poyang.

# Mount Lushan

Mount Lushan is in the southeast of Jiangxi Province, facing the Yangtze River to the north and Lake Poyang (the largest freshwater lake in China) to the east. More than 1,474 m above the sea level, Mount Lushan features 16 natural wonders and 474 scenic spots. Known as "the most beautiful mountain under heaven," Mount Lushan is one of the best summer resorts in China. People like to enjoy its three wonders: the cloud sea, the waterfalls, and the craggy cliffs. Because of the surrounding water, Mount Lushan has rainy and humid weather. As a result, much of the scenery involves water: there are 22 waterfalls, 18 rapid rivulets, 14 lakes and ponds. For visitors, Mount Lushan is also one of the nine best spots for watching sunrise in China.

Mount Lushan is also historically and culturally famous. Numerous famous persons in the past 2,000 years have visited Mount Lushan and left many beautiful poems and paintings.

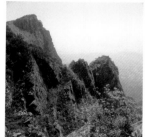

The Academy of the White Deer Cave, one of the oldest institutions for higher learning in China, has been there for more than 10 centuries.

Mountain flowers in full bloom

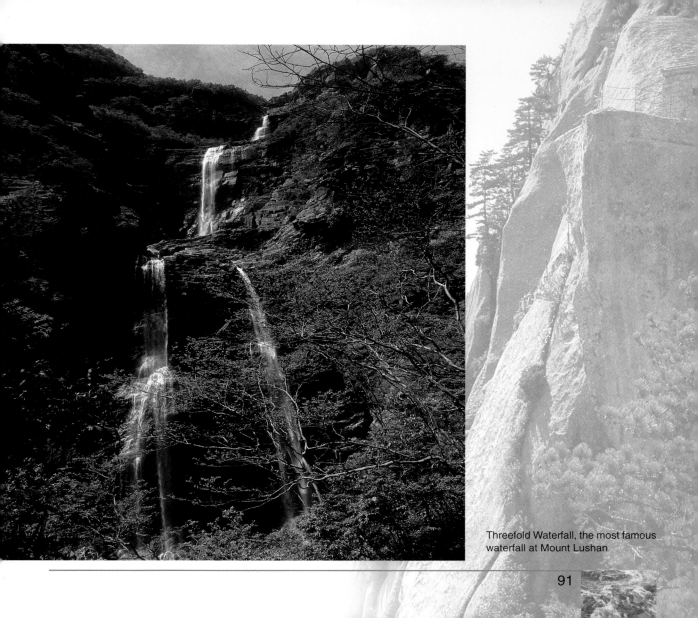

Threefold Waterfall, the most famous
waterfall at Mount Lushan

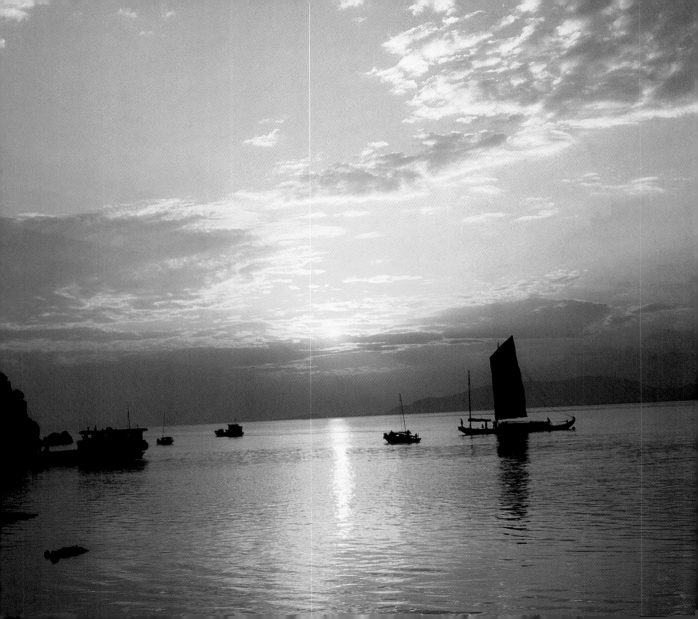

# Mount Wuyi

Situated in the south of Wuyishan City, Fujian Province, Mount Wuyi is a famous historical and cultural mountain in China. Mount Wuyi is noted for its fantastic and beautiful scenery. Belonging to a subtropical forest ecosystem of central Asia, Mount Wuyi has typical Danxia mountain formation, well-preserved vegetation, and is rich in rare ecological resources. With its crystal clear water and elegant green peaks rising to the sky, Mount Wuyi has mountains amid water and water among the mountains. The best choice for traveling Mount Wuyi is by bamboo raft.

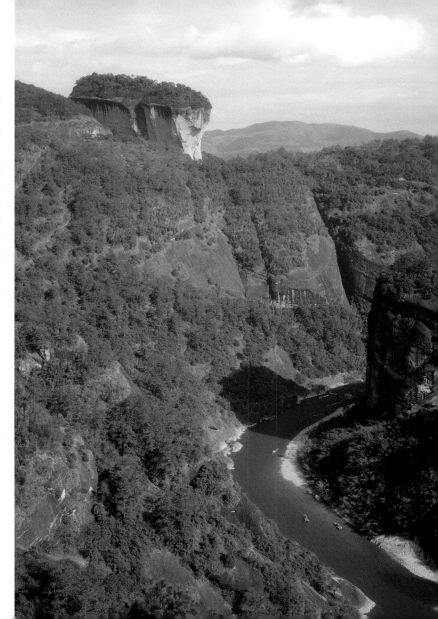

Traveling on bamboo raft under Dawang (King's) Peak

◀Chanting on a returning fishing boat at dusk on Lake Poyang

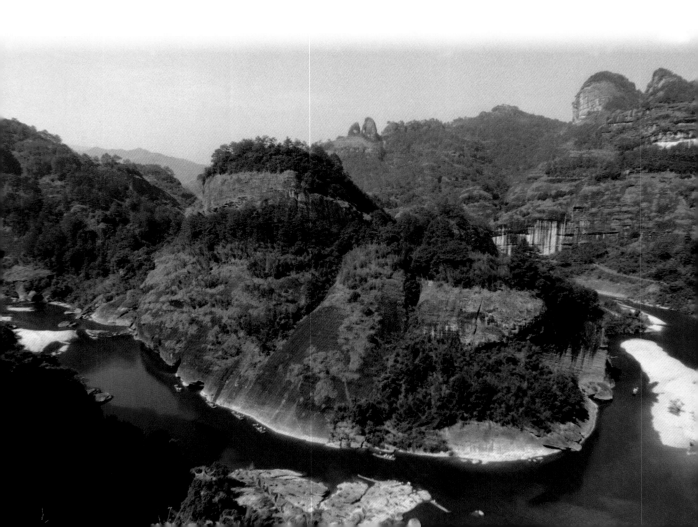

Liuqu Stream (Six-Turn Stream)
surrounded by mountains

# Mount Jiuhua

Mount Jiuhua, the Mountain of the Nine Lotuses in Chinese, is located in Qingyang County, Anhui Province, as one of the four great Buddhist mountains in China (the other three are Mount Emei in Sichuan, Mount Wutai in Shanxi and Mount Putuo in Zhejiang).

Starting in the Tang Dynasty, temples were built on the mountain, and the renovation or enlargement of old temples lasted for centuries. In its prime, Mount Jiuhua had over 300 temples and 5,000 Buddhist monks and nuns in residence. At present, there are over 50 well-preserved temples and more than 6,000 Buddha sculptures.

With an area of about 60 sq miles, the 99 peaks of Mount Jiuhua are covered with verdant vegetation. Both Buddhists and other visitors can refresh their spirits by enjoying the picturesque beauty and tranquility of Mount Jiuhua.

Temple Zhiyuan built in the Ming Dynasty

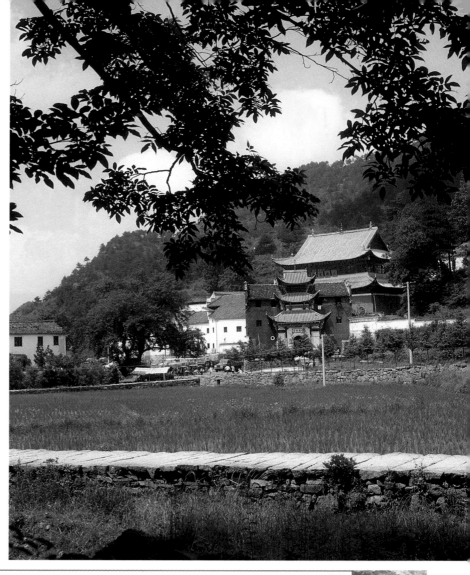

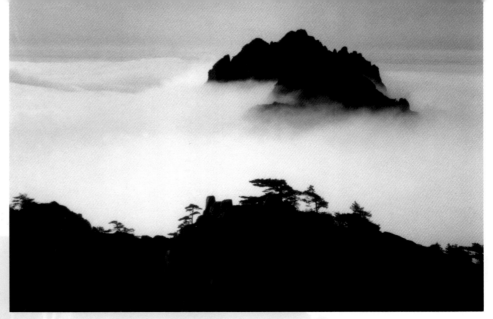

Lotus Peak

# Mount Huangshan

As we know, the ancient Chinese people selected five great mountains in the country, that is, Mount Taishan, Mount Hengshan (south), Mount Huashan, Mount Songshan and Mount Hengshan (north). But whoever chose the mountains must have never seen Mount Huangshan, because as a Chinese saying goes, "After returning from Mount Huangshan, there is no need to see other mountains."

Located in the south of Anhui Province, Mount Huangshan has 72 peaks, 24 streams, three waterfalls and two lakes. Lotus Peak, Mount Huangshan's highest, is 1,864 m above sea level. The four wonders of Mount Huangshan are strangely shaped pines, grotesque rocks, cloud seas, and hot springs.

The beauty of Mount Huangshan is so enchanting and unique that countless painters and poets have visited Mount Huangshan to find inspiration. The Huangshan School of painting originated in the later years of the Ming Dynasty from the inspiration of Mount Huangshan's precipitous peaks. The poems and paintings about Mount Huangshan left by these artists and men of letters add cultural charm to the great mountain.

The most famous scenic spots of Mount Huangshan include Lotus Peak, the Rock That Flew from Afar, and the Welcoming Guests Pine. At present, Mount Huangshan is a national park and is on UNESCO's World Heritage List.

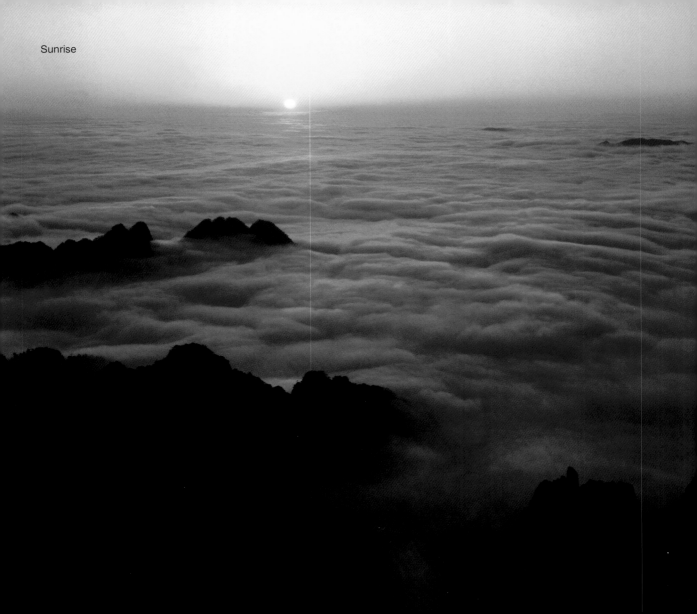
Sunrise

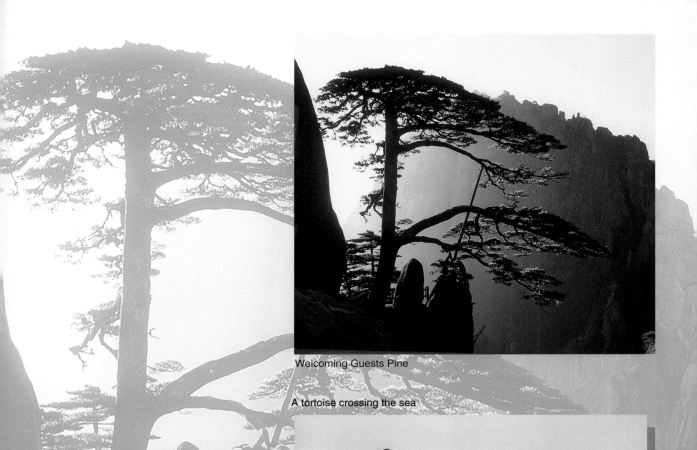

Welcoming Guests Pine

A tortoise crossing the sea

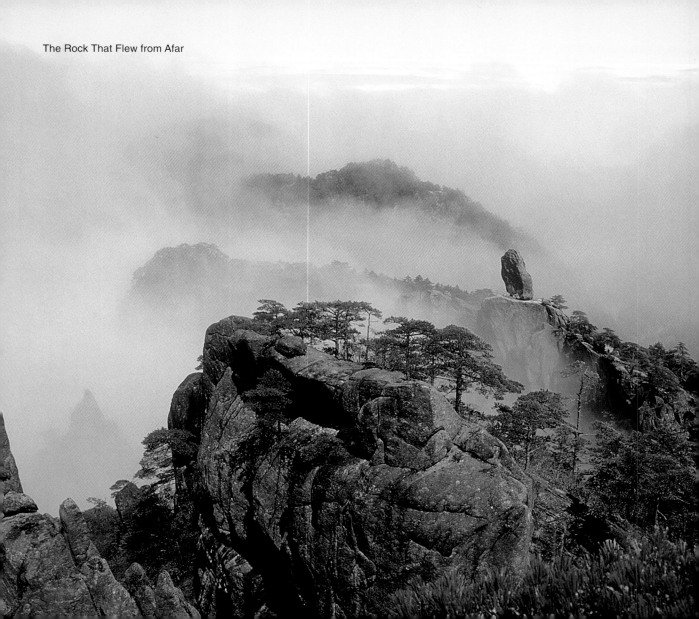

The Rock That Flew from Afar

Outside view of Temple Huiji

## Mount Putuo

Mount Putuo, strictly speaking, is one of the Zhoushan Islands in Zhejiang Province, but it contains lush green mountains.

As one of the four great Buddhist mountains in China, Mount Putuo was dedicated to Guanyin, the Goddess of Mercy, by imperial decree in the 13th century. Mount Putuo, the famous paradise haven, was dubbed "Buddha Land in the Vast Sea" in the Song Dynasty (960 - 1279). There are three well-known monasteries at Mount Putuo: Temple Puji (Universal Relief), Temple Huiji (Wisdom and Blessing), and Temple Fayu (Rain of Law). Some of the island's scenery, such as the Thousand-Pace Golden Sands and Potalaka Mountain, are very impressive.

With a favorable climate in all seasons and picturesque views, Mount Putuo is not only a holy land for Buddhist followers but also a wonderful place for tourists.

Tossing green waves

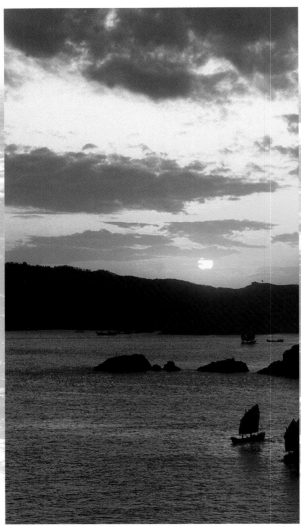

Fishing boats
return at dusk

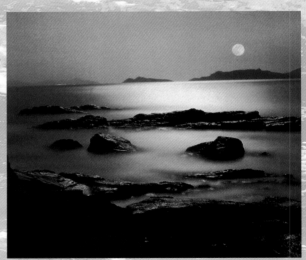

The moonlit sea

The Goddess of Mercy▶
Avalokitesvara Bodhisattva
worshipped at Mount Putuo

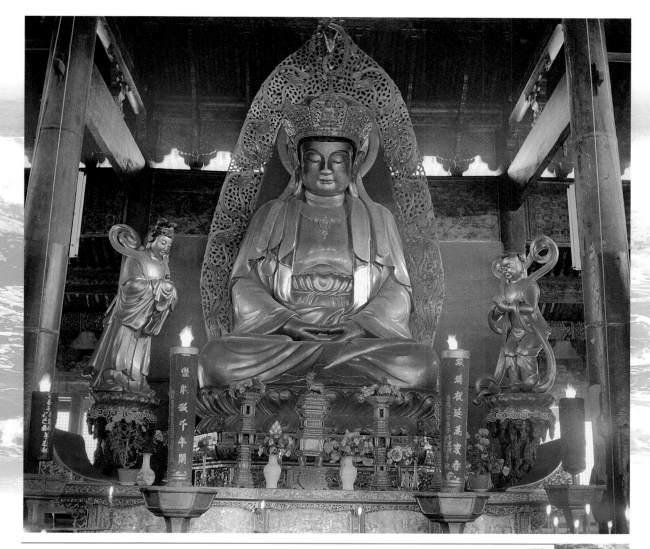

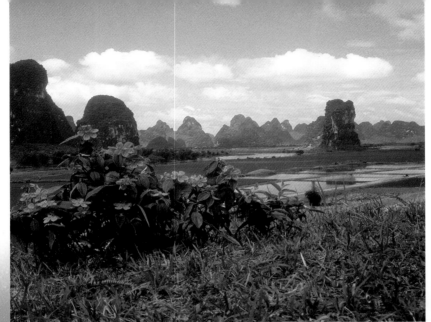

Spring on the
Lijiang River

## The Lijiang River

What scenery is the finest under heaven? A Chinese may tell you the scenery of Guilin. The city, in the northeast of Guangxi Zhuang Autonomous Region, is noted for its verdant mountains, beautiful waters, magnificent crags, and fantastic caverns. The 437 km Lijiang River's source is at Mount Mao'er at Xing'an County northeast of Guilin, and it passes through Guilin, Yangshuo, and other places. The 83-kilometer-long waterway from Guilin to Yangshuo forms a gallery of landscape painting. Among the pinnacles and hillocks, the Lijiang River is just like a jade ribbon, as a poem says: "The river is a green silk ribbon, and the hills are jade hair-pins."

Why not rent a boat to travel leisurely down the Lijiang River? You will find yourself in a traditional Chinese landscape painting.

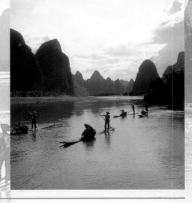

A fishing boat returning home at dusk

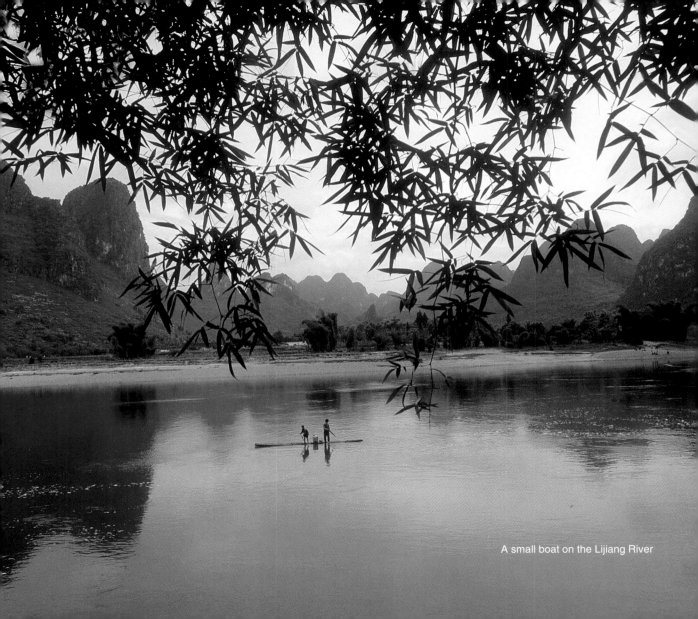

A small boat on the Lijiang River

Mount Ali's lush foliage

## Mount Ali

Mount Ali, a famous mountain in Taiwan Province, China, is noted for its forests, cloud seas, and sunrise. It has an abundance of rare superior woods for construction, including Taiwan fir, Chinese hemlock, and Japan cypress. At daybreak on a clear day, to watch the sunrise in the cloud sea from the summit of Mount Ali is truly spectacular. The cloud sea of Mount Ali is one of the eight most beautiful scenes of Taiwan. As a famous scenic area, Mount Ali is the best summer resort in Taiwan.

106

# Distribution of Some of China's Famous Mountains and  Rivers

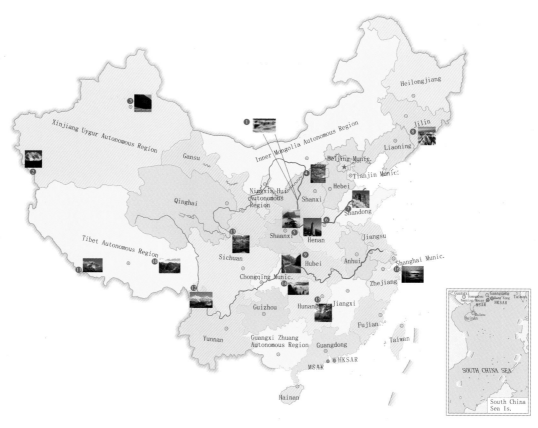

❶ The Yellow River
❷ Kunlun Mountains
❸ Mount Tianshan
❹ Mount Hengshan (Shanxi)

❺ Mount Huashan
❻ Mount Songshan
❼ Mount Taishan
❽ Mount Changbai

❾ The Yangtze River
❿ Yarlung Zangbo River
⓫ The Himalayas and Mt Everest
⓬ Shangri-la

⓭ Jiuzhaigou (Jiuzhai Valley)
⓮ Wulingyuan
⓯ Mount Hengshan (Hunan)
⓰ Mount Putuo

图书在版编目（CIP）数据

中国名山大川 ／ 于力 编．－北京：外文出版社，2002.7
（中华风物）

ISBN 7-119-03063-9

I. 中… II. 于… III. ①山(地理)－简介－中国－英文②水
(地理)－简介－中国－英文 IV. K928

中国版本图书馆 CIP 数据核字（2002）第 026218 号

"中华风物"编辑委员会

顾　　问：蔡名照　赵常谦　黄友义　刘质彬
主　　编：肖晓明
编　　委：肖晓明　李振国　田　辉　呼宝珉
　　　　　房永明　胡开敏　崔黎丽　兰佩瑾

责任编辑：蔡莉莉　程　宇
英文翻译：程　宇　顾文同
英文审定：郁　苓
摄　　影：刘春根　孙永学　孙树明　孙志江
　　　　　罗文发　高纯瑞　谢　军　杜泽泉
　　　　　谷维恒　茹遂初　刘世昭　房海峰
　　　　　郎　琦　黄禄奎　王春树　徐明强
　　　　　佟永江　张韫磊
内文设计：蔡　荣
封面设计：蔡　荣

中国名山大川

于力　编

ⓒ 外文出版社

外文出版社出版
（中国北京百万庄大街 24 号）
邮政编码：100037
外文出版社网页：http://www.flp.com.cn
外文出版社电子邮件地址：info@flp.com.cn
　　　　　　　　　　　　sales@flp.com.cn
外文出版社照排中心制作
天时印刷(深圳)有限公司印刷
中国国际图书贸易总公司发行
（中国北京车公庄西路 35 号）
北京邮政信箱第 399 号 邮政编码 100044
2002 年(24 开)第 1 版
2002 年第 1 版第 1 次印刷
（英文）
ISBN 7-119-03063-9/J·1594(外)
05800(精)
85-E-539S